SAN FRANCISCO

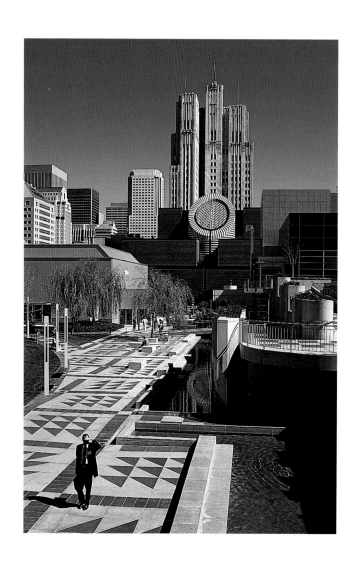

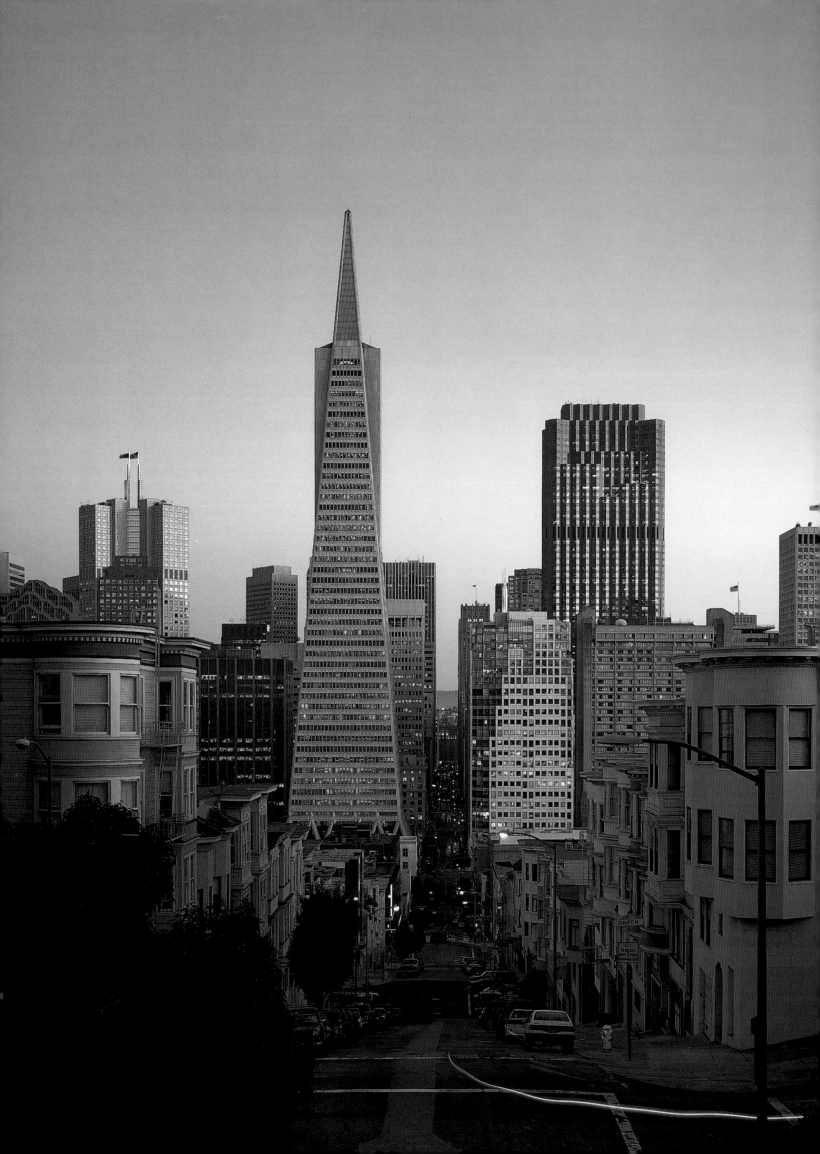

SAN FRANCISCO
POINTS OF VIEW

PHOTOGRAPHY BY DAVID WAKELY

ESSAYS BY DAN HARDER

GRAPHIC ARTS CENTER PUBLISHING®

International Standard Book Number 1-55868-296-1
Library of Congress Book Number 96-76333
Photographs © MCMXCVI by David Wakely
Text © MCMXCVI by Graphic Arts Center Publishing®
An imprint of Graphic Arts Center Publishing Company
P.O. Box 10306, Portland, Oregon 97296-0306
503/226-2402
President • Charles M. Hopkins
Editor-in-Chief • Douglas A. Pfeiffer
Managing Editor • Jean Andrews
Photo Editor • Diana S. Eilers
Designer • Kerry Crow
Production Manager • Richard L. Owsiany
Book Manufacturing • Lincoln & Allen Co.
Printed and Bound in the United States of America
Second Printing

HALF TITLE PAGE: *A new core of culture in San Francisco is the Yerba Buena Center around which swirls a gargantuan dance of old and new buildings.* FRONTISPIECE: *Literally built on the bay, the Transamerica Building is, like most buildings in the financial district, anchored on landfill that includes not only rock, sand, and cement but the anchors, keels, and timbers of over forty ships abandoned in the former tidewaters below.* FACING PAGE: *The beauty of San Francisco is as much in what it sees as what it looks like … and among the most beautiful things it sees are the oak-sloped hills of Marin.*

Introduction

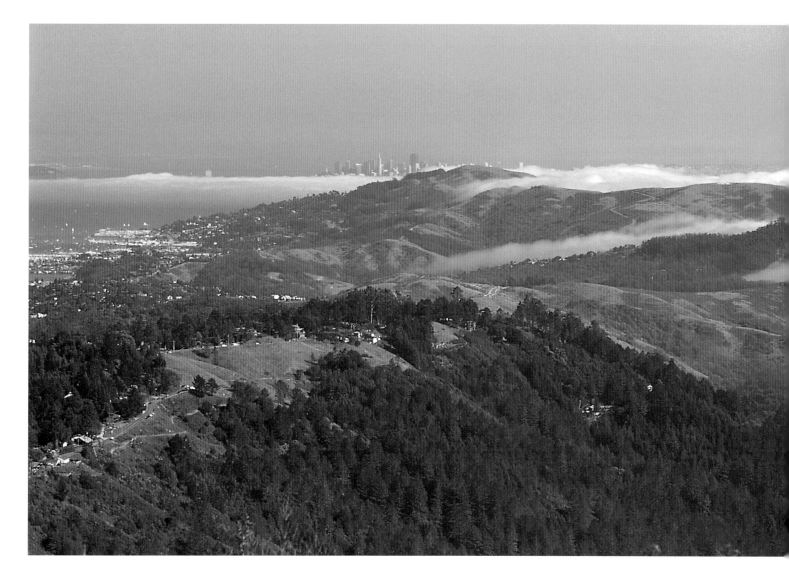

I t doesn't last very long and it only happens once a year, and yet it determines much of the how and the why we are what we are. "It" is the annual and short-lived greening of the hills around here—and "here" is San Francisco.

If we were not built on a tight little fist at the end of an arm of land, we would not see what surrounds us quite so well. But here we are—uniquely placed for a city this size—with water, lots of water, close around us, and hills, lots of hills, farther off. Indeed, the beauty of San Francisco is as much in what it sees as in what it looks like, and what we see is this: an ocean, a bay, a narrow channel called the Golden Gate, and a jumble of soft hills off in the distance.

And it is not just these distant hills that we have to look at, green and glorious, once a year, but our own—forty-three or so—that rise steeply in our midst. Many of these "hills" are upholstered in much the same stuff they wore before Portola's men clambered over them to "discover" the San Francisco Bay. And it is this stuff, on our hills and the hills beyond, that turns a most striking green for a couple months every year. In years of drought, the green comes

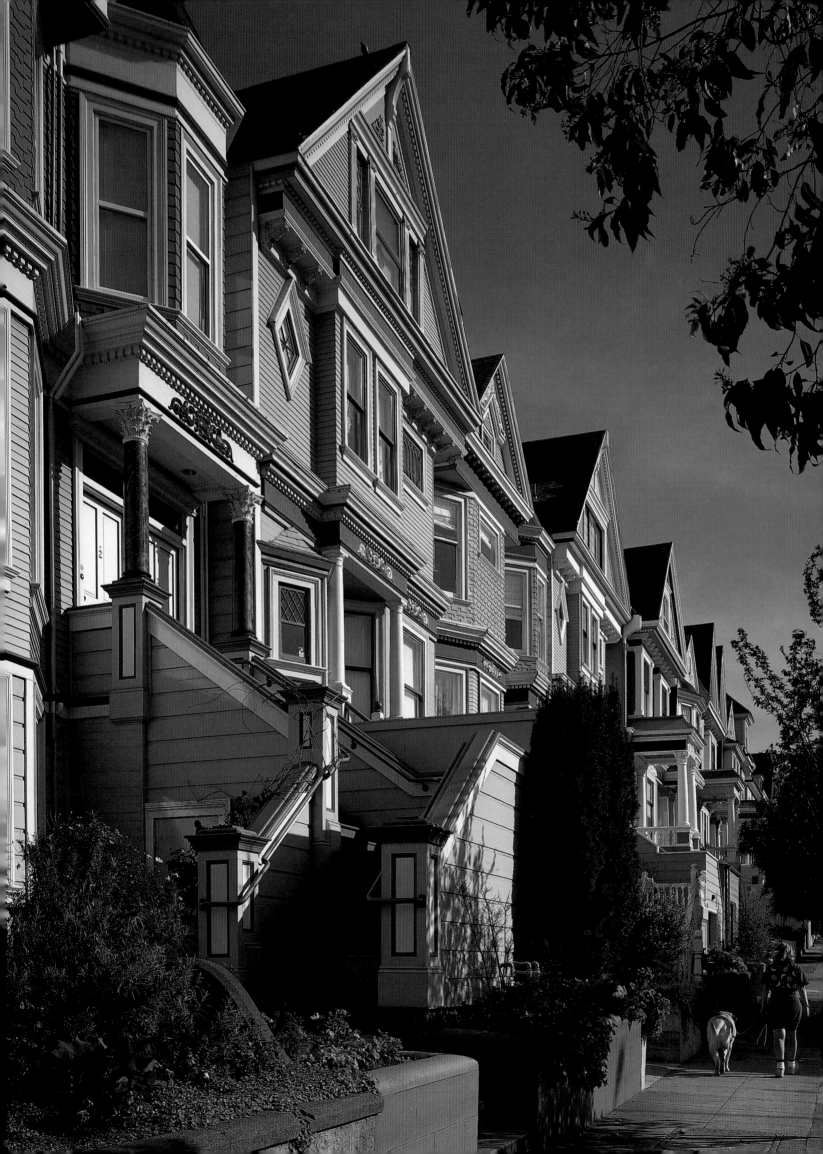

late, clings to the hills for only a few weeks, then turns to a beige stubble for the rest of the year.

Still, whether in years of drought or years of mudsliding floods, the green comes in a sudden burst after the first days of the first serious rain. Instantly, we flourish. Instantly, we grow. Instantly, we become something we weren't just a little while before. To a great extent, this has been the history and pattern of the city, the "instant city" as Frederick Turner has called it. With unpredictable regularity, the ground shakes, the hills slide, the place burns, a warm and sunny morning becomes a cold and foggy afternoon, fortunes are discovered (and almost as quickly disappear), and it all turns green … instantly.

Of course, things change elsewhere, too. This is, after all, America where traditions are traditionally overthrown almost as soon as they are defined. And of course, the forces of nature are fickle wherever they are forceful—and they are forceful pretty much everywhere. The difference here is the scope of the changes. The fog doesn't just turn a warm noon into a cold and wind-rattled afternoon. The atmosphere, neither quite completely sky nor sea, becomes a moist and swirling shawl, and the whole meaning of summer is changed. Someone discovers gold in "them thar hills"

FACING PAGE: *What do you do when you've got a lot of wood, a little bit of space, and a local flare for extravagance? In the Victorian era you built rows of houses right next to one another and embellished their faces with a variety of well-turned shapes.* BELOW: *Neither Washington Square nor what surrounds it in North Beach can be defined as "square." Recently, in fact, the area was described as a kind of "nouvelle Europe," rich with all manner of one-of-a-kind places to be.* FOLLOWING PAGES: *New businesses are helping revive the glory around South Park, the richest address in San Francisco before the cable car hauled that distinction to the top of Nob Hill.*

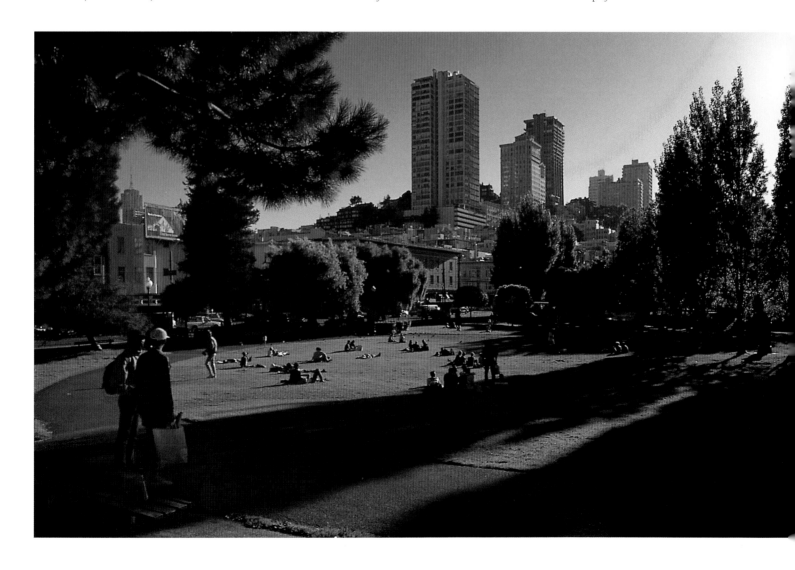

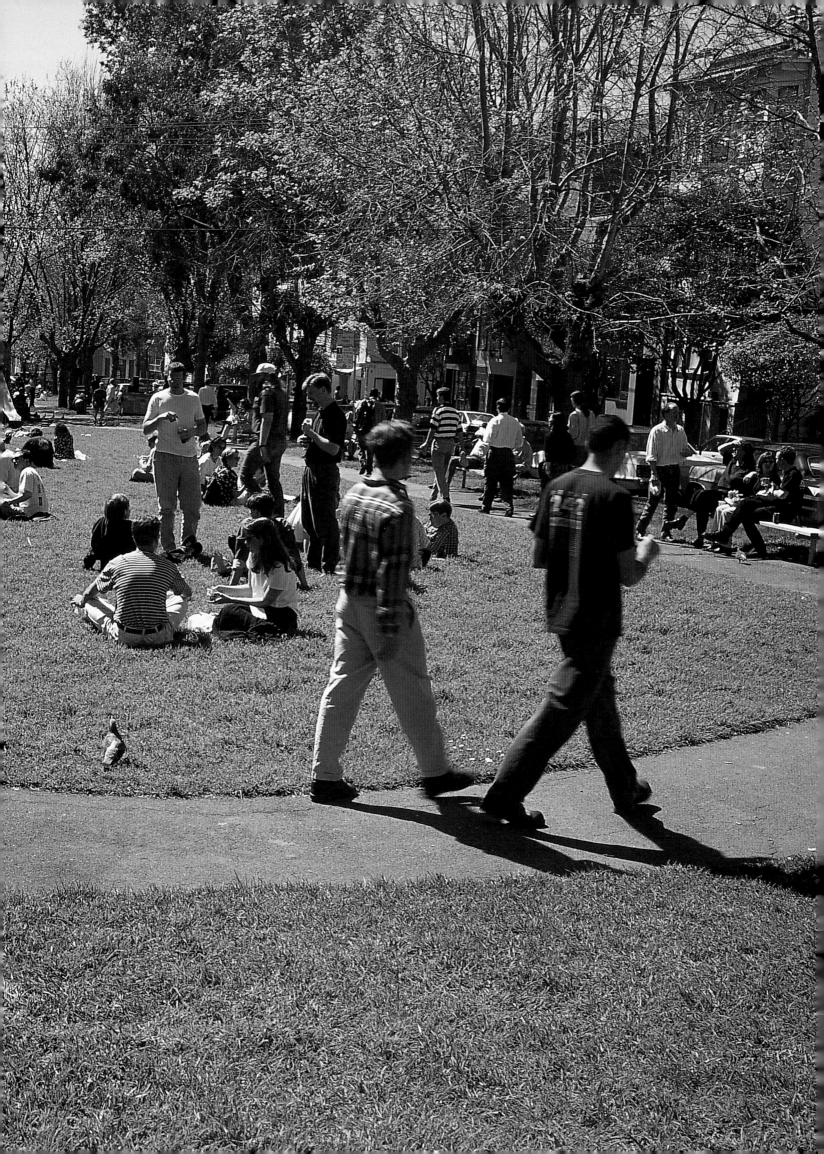

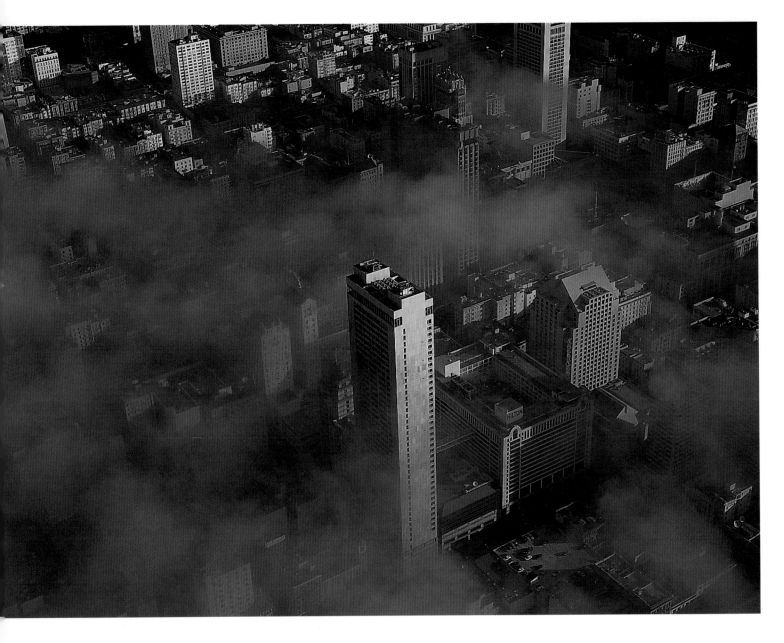

and a sandy, windswept outpost becomes "the Queen of the Pacific." A few people sing a few songs in and about San Francisco and the world shows up, dressed in paisley and necklaced with peace signs.

And, of course, there are those predictably unpredictable rumblings from below. In the jolt of '89, I met a man who had rushed out of the Fairmont Hotel still dripping and clad only in a hotel robe. He was visiting the city for a convention of envelope manufacturers. Utterly shaken and still, in fact, shaking—despite the 80-degree fall weather (another "normal" anomaly around here), he asked me where the airport was. I told him, and then explained that there would be no way to get there. The roads and freeways would either be buckled or hopelessly jammed. No, no, he wasn't going to drive there. He was going to walk—right then and there, barefoot, wet, and with nothing but a robe and a wallet. Back to Indiana where they did not have those kinds of things. And off he started, south towards the airport.

A few days later, I ran into the fellow again—hard, though, to recognize without his hotel-issue terry cloth. Had he ever made

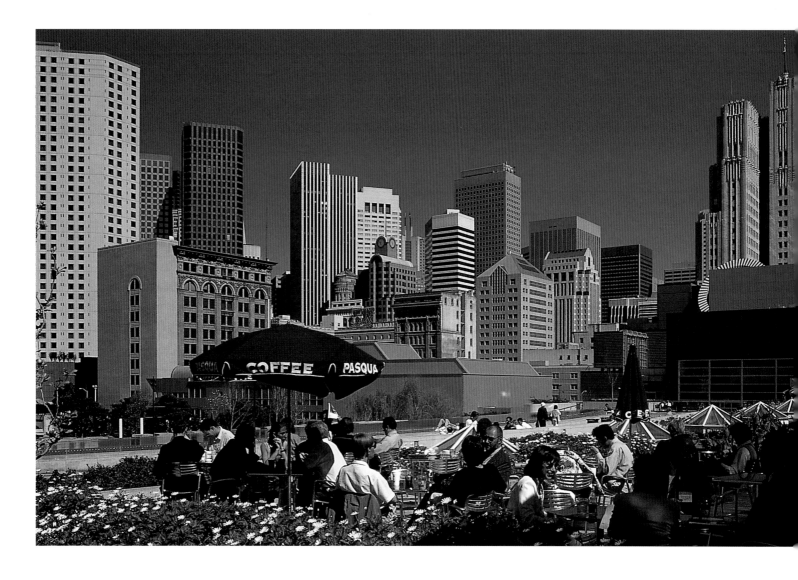

it to the airport, I inquired. No, no. He had come to his senses a couple of blocks later (the broken glass may have persuaded his bare feet before his mind realized the folly). And now, he never wanted to leave. All those people wanting to rebuild everything. All that "reconstructive" energy. "It's like," he confided, "you've just fallen out of an airplane and realize you've survived. You get up, dust yourself off, and ask, with kind of a smile, so what's next?"

Indeed.

FACING PAGE: Italian fishermen used to call the local fog "Santa Niebla," referring to Our Lady of the Fogs, who drew her grey veils from the sea. We may have lost her language, but her veils are still here, trailing across the city. ABOVE: "It's an odd thing," Oscar Wilde once remarked, "but anyone who disappears is said to have been seen in San Francisco. It must be delightful to possess all the attractions of the next world...." This seems particularly likely here at Yerba Buena Center where one is apt to see almost anyone. FOLLOWING PAGES: For some, Jerry Garcia's death and poignant memorial service in the Golden Gate Park signaled the end of an era. For others, it renewed the conviction that "The Dead" and their celebratory rock and roll will never die.

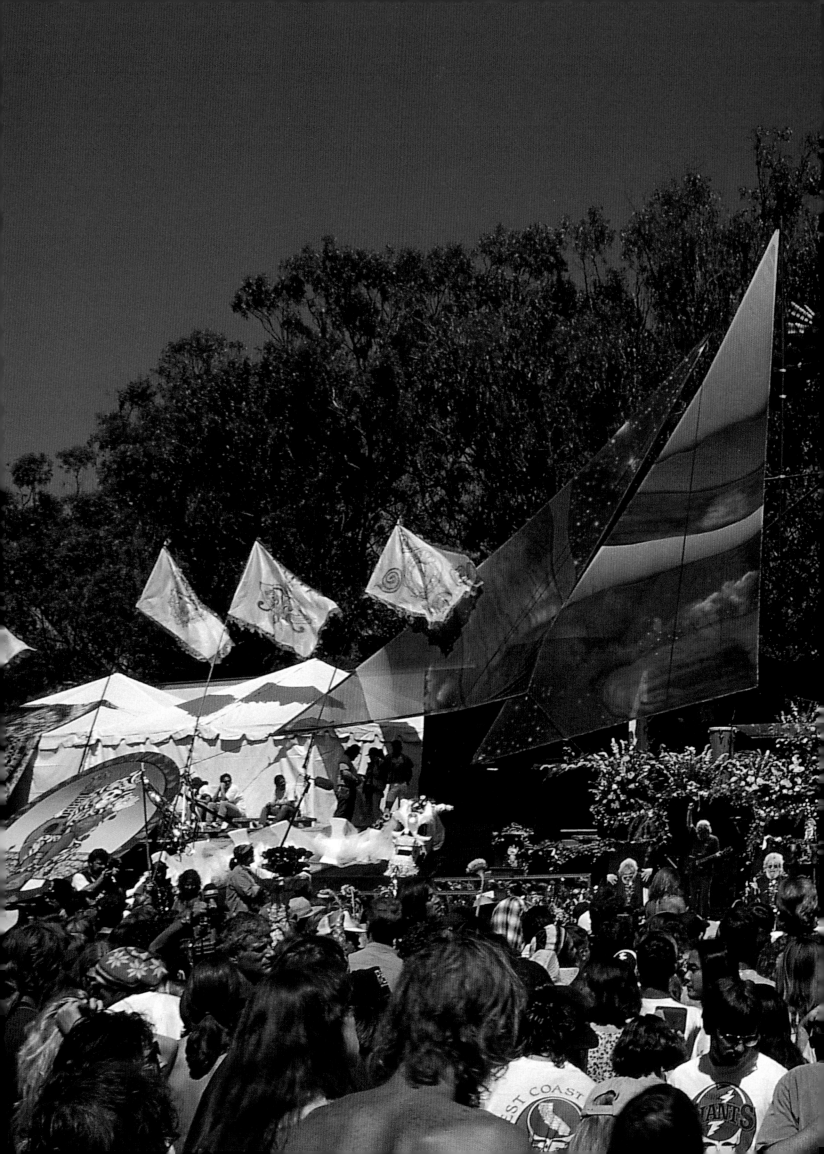

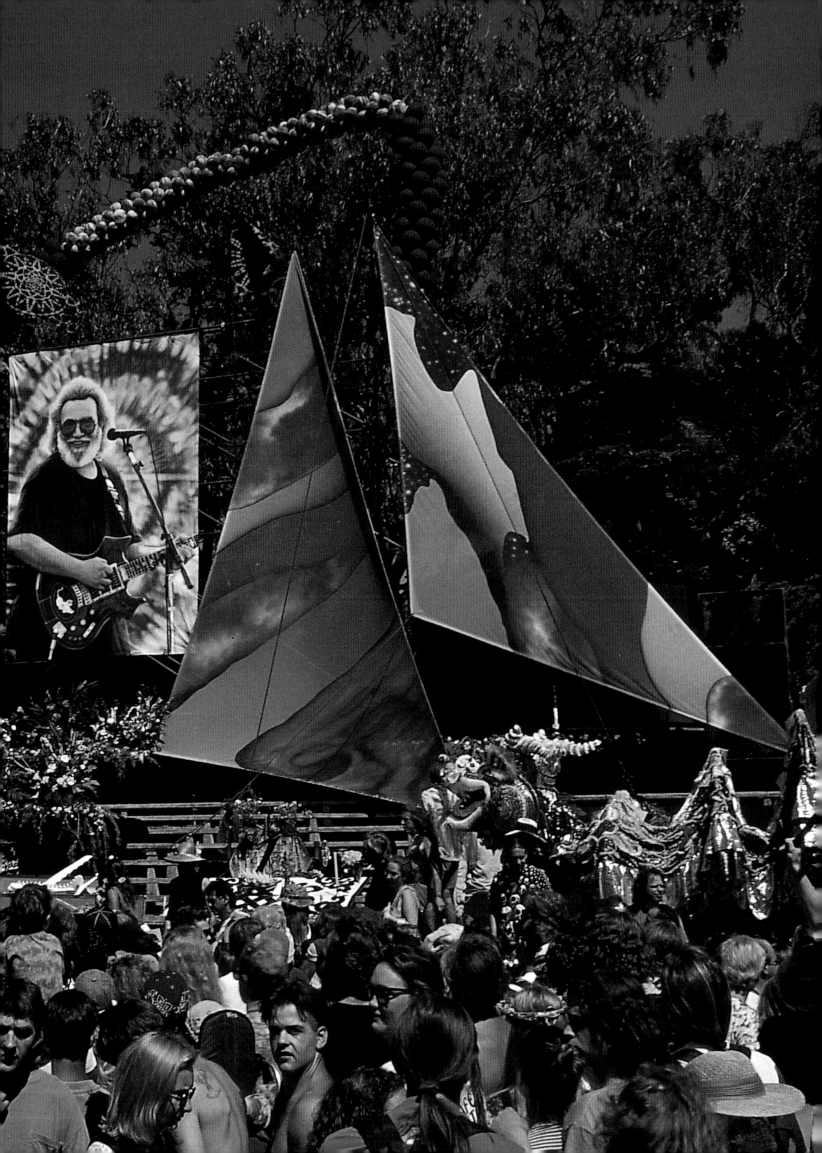

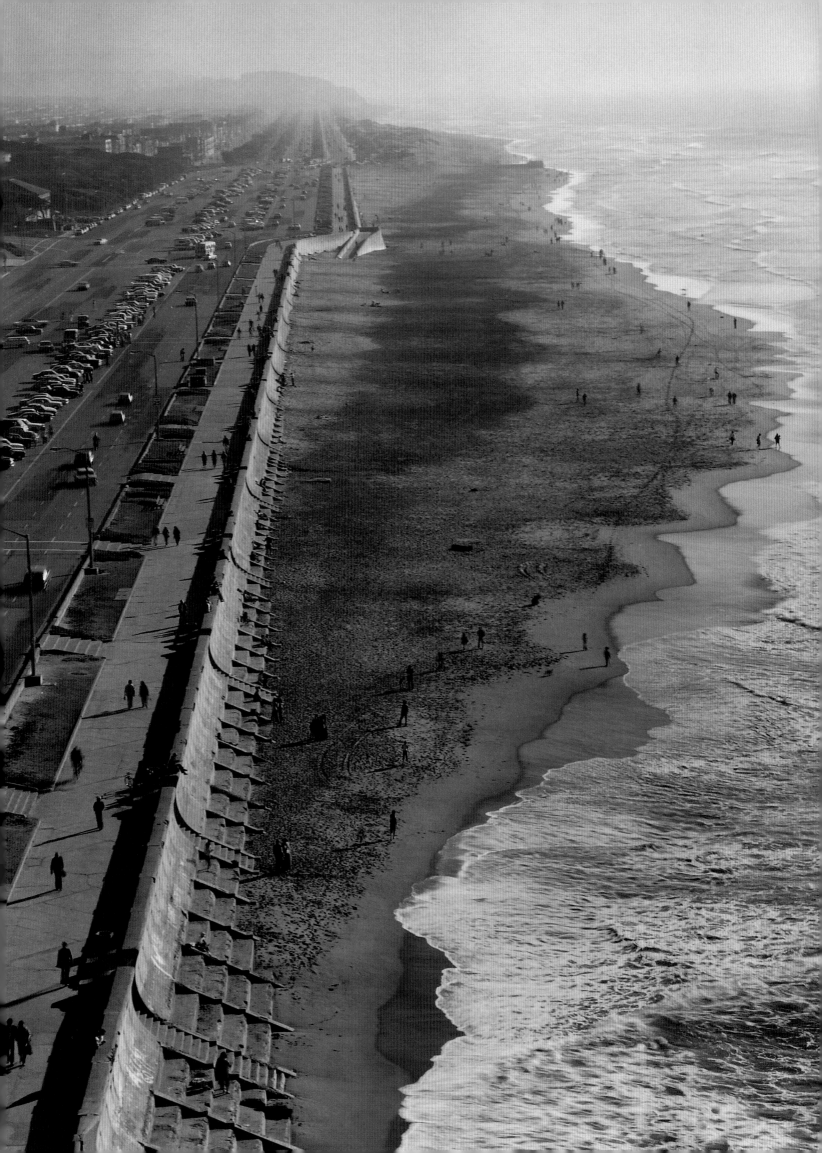

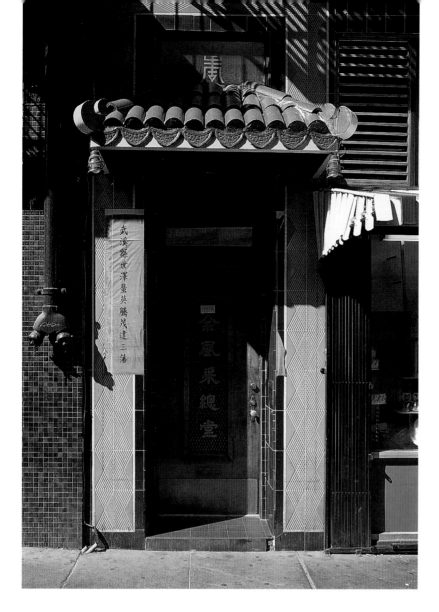

FACING PAGE: *Not exactly known for its balmy/beachy weather, San Francisco does, nonetheless, have some very long beaches that are always beautiful to stroll along, and often calm and sunny enough for serious sunbathing.* LEFT: *Part of the picturesque in San Francisco is the overlayering of cultural effect—like a bright Chinese doorway to an otherwise dull building.* BELOW: *Easy it isn't, but breezy it almost always is, which is why many consider the San Francisco Bay to be the best place in the world for yacht racing.*

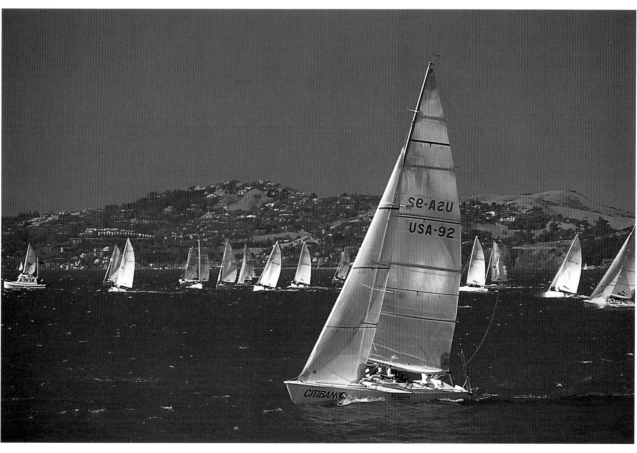

BELOW AND RIGHT: *Recreation comes in many shapes and sizes—from hanging out with "hair" to trimming a miniature jib or skating a jig in the park.* FACING PAGE TOP: *While three move to the ancient and salubrious choreography of Tai Chi in the background, three prance in a frozen pose in a fountain at the top of Nob Hill.*

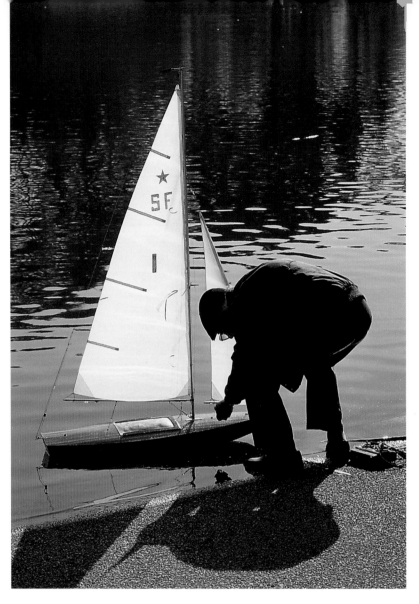

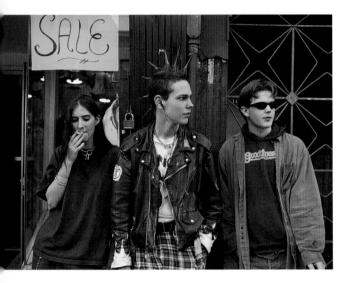

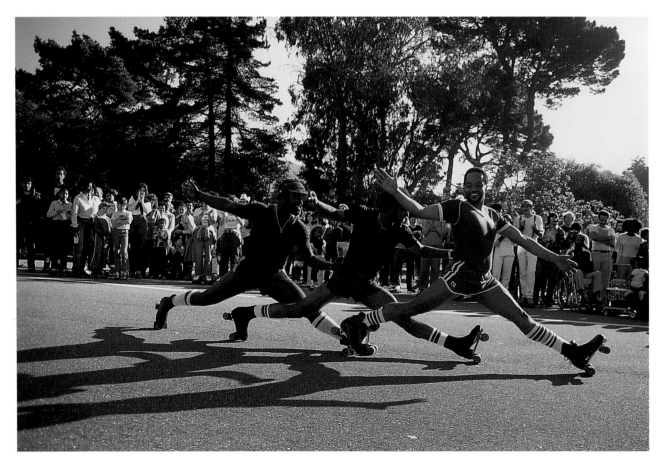

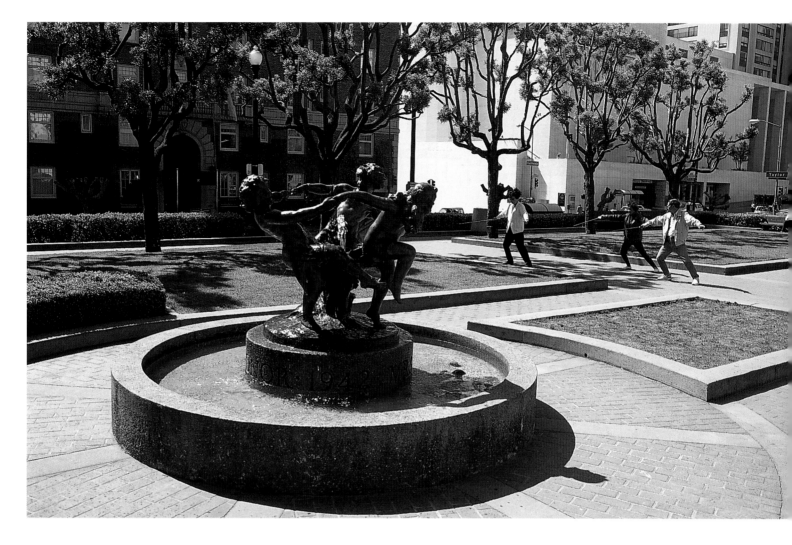

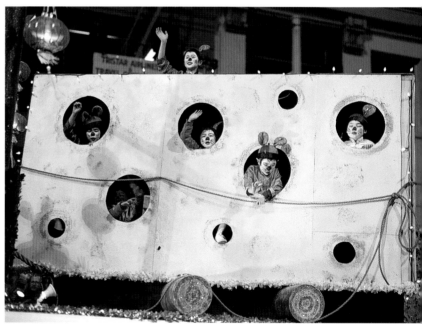

LEFT: *Ambrose Bierce once described San Francisco as "the moral penal colony of the world…" and the Tosca "cappuccino"— created, significantly, during Prohibition—may very well be the "colony's" most appropriate elixir: espresso, cream, and a whole lot of whiskey.* ABOVE: *Little rodents peek through holes in the cheese during the Chinese New Year's Parade—here, celebrating the arrival of the Year of the Rat.*

ABOVE: *Thick as these walls are at the old garrison at Fort Point, nothing could keep out that cold, wet wind, particularly as it blows, ironically in summer, here at the mouth of the Golden Gate.* FACING PAGE: *Attractive architecture may belie the fact that we are* the second-densest city in America. FOLLOWING PAGES: *When summer's over, that's when the real summer begins. Nothing is more beautiful than those warm, clear days—say, in mid-October—when we look and feel almost as Mediterranean as we do Pacific.*

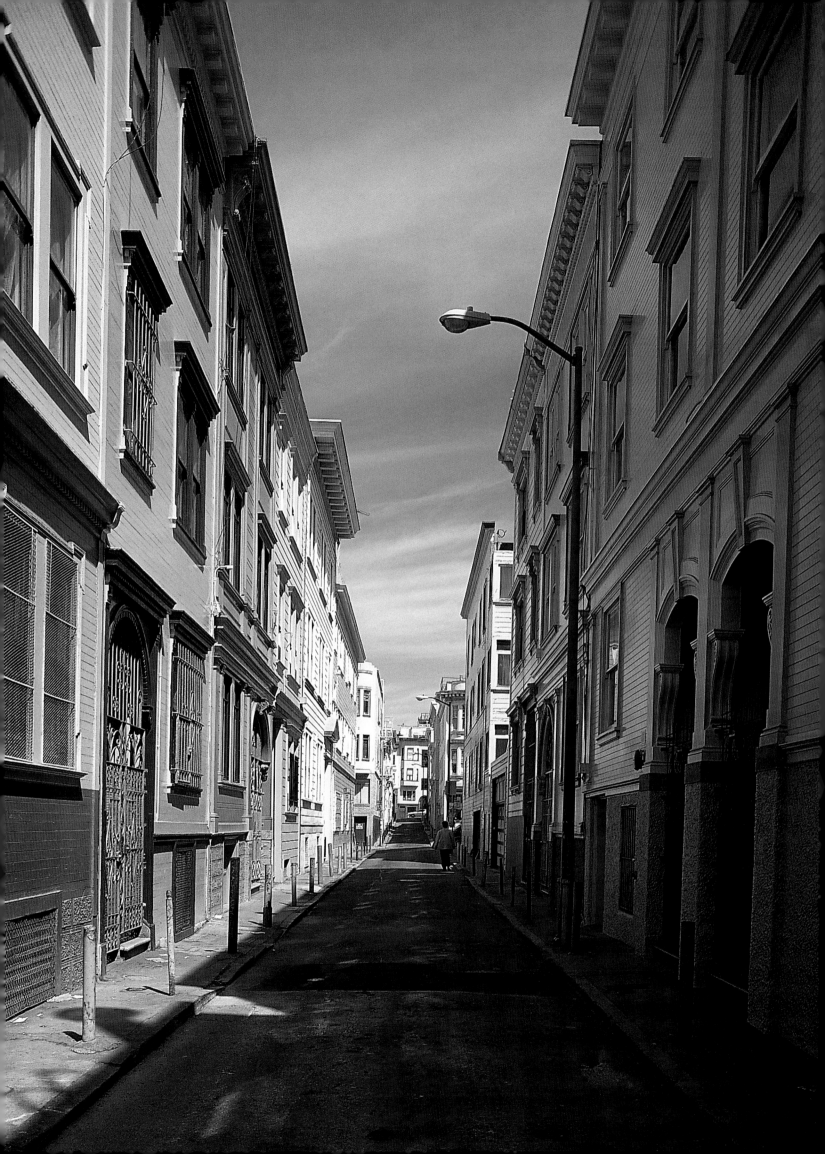

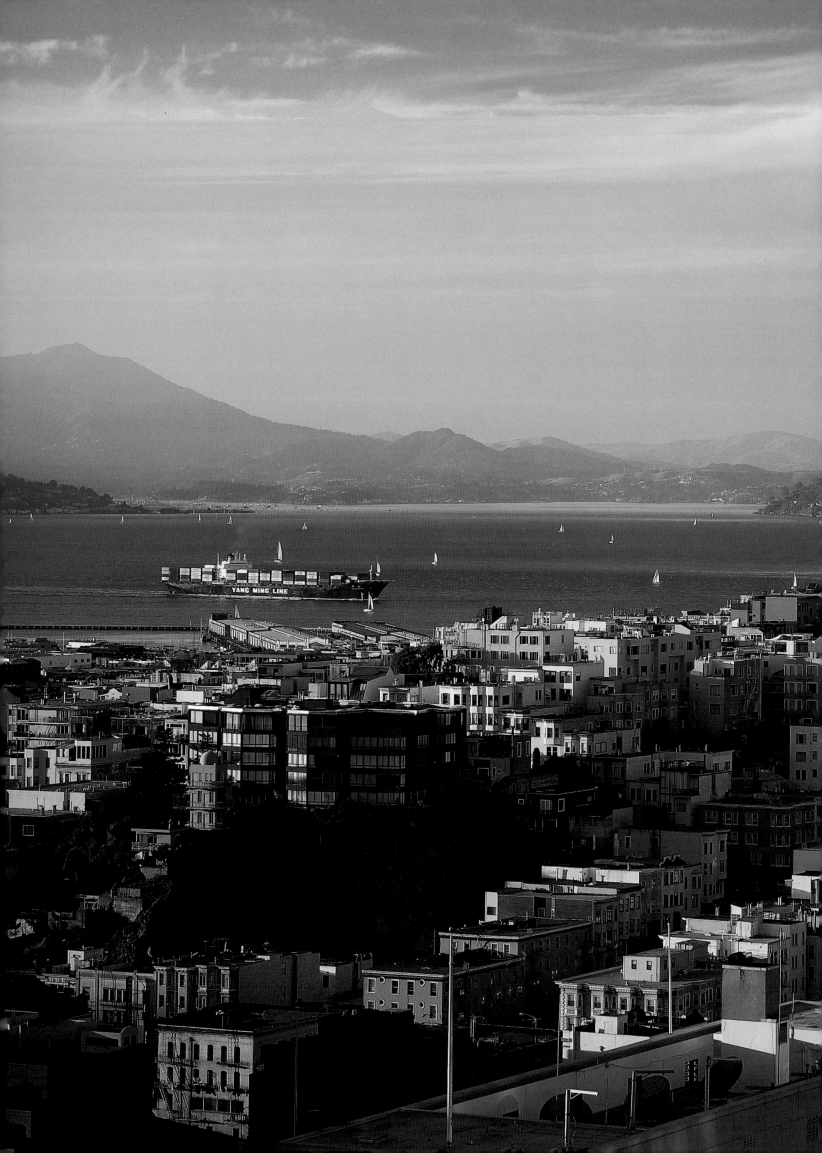

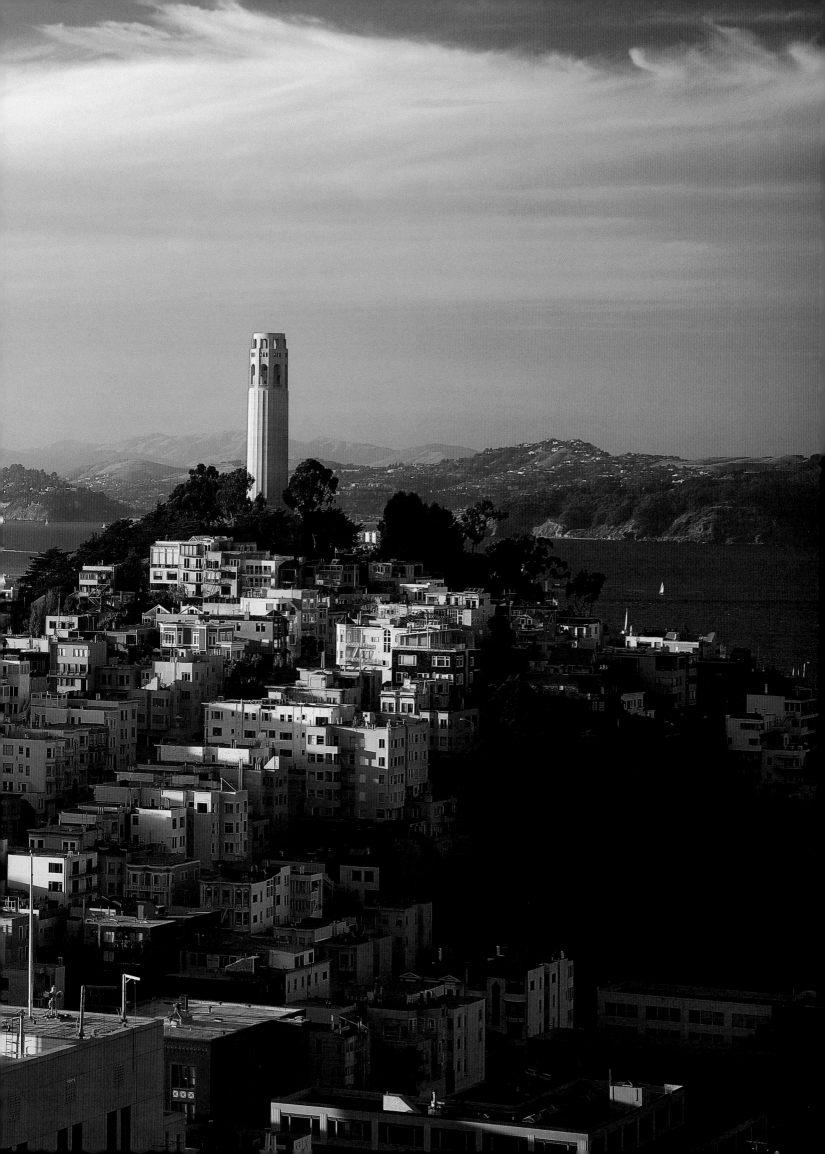

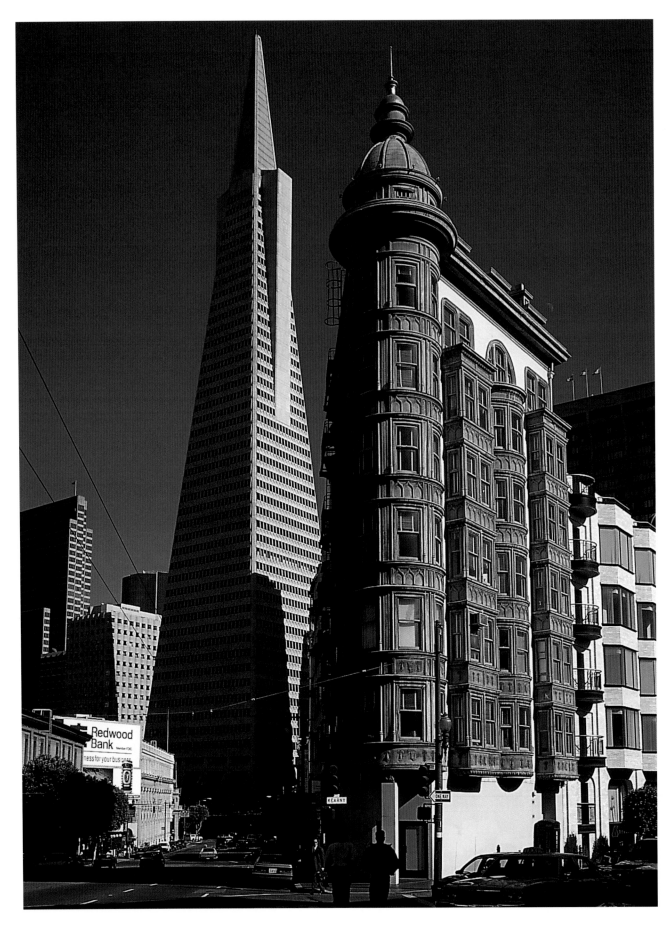

ABOVE: *Along the once much wilder Barbary Coast, we look down Columbus Avenue (the old cow path to Cow Hollow) past the Columbus Tower to San Francisco's tallest building, the Transamerica Pyramid.*

FACING PAGE: *As if it were soft gray jumbles of butter, the fog often sits at the top of our hills, not quite hot enough to melt over the side, not quite cold enough to congeal.*

22

The Scenic "Seen"

Whereas the Spanish outpost once known as Yerba Buena was obliquely discovered and almost exclusively supplied by way of the ocean; whereas Captain John B. Montgomery came to lower one flag and raise another by way of the sea; whereas the majority of gold-hungry hordes floated into the bay—again, by way of the Pacific; and whereas the wind and the fog that define (one might even suggest "defy") our summers, as well as the temperatures that rarely rise above 80 degrees or sink below 50, as well as all of our shipping, so many of our cultures, and even so much of our solitude are brought to us by way of the big flat wet thing to the west, we have chosen, at least structurally, to turn our back on it. Pacific it may be, but the ocean is a bit much for most of our grounded needs.

We have moored our ships, built our skyscrapers, and perched the densest parts of our "collective" on the slopes and in the valleys that incline toward the bay. Alas for the tourist who wakes too late, one of the most stunning experiences of that bay is to watch the sun rise under a blanket of morning fog. From any of the hills facing east on a morning when the fog is mostly only a San Francisco thing, the sunlight spreads golden across the water while the sky above is an iridescent, patchwork gray. It is, with the skyline of downtown looming up somewhere in the middle distance, a view at the same time both soft and startling.

And yet, without that jostling ocean at our backs, the fog wouldn't happen, the bay would simply be a lake, and our very reason for being would be … well, questionable.

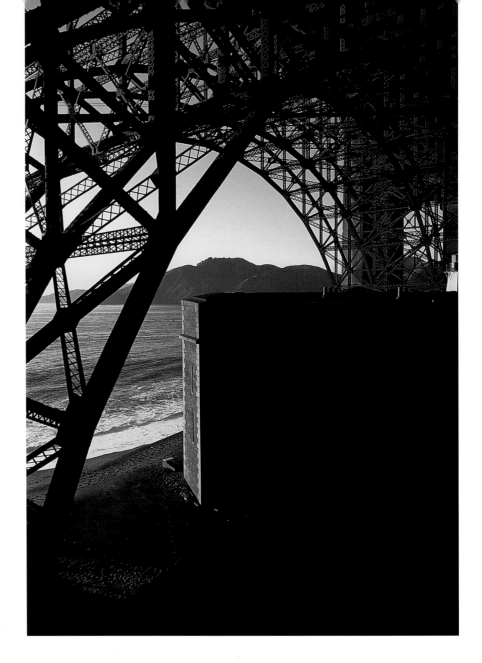

RIGHT: *The Spanish "Castillo" was razed to make way for Fort Point, its American counterpart. Unwilling to raze it one more time, the architects of the Golden Gate Bridge chose to vault right over it.* FACING PAGE: *Where the surf is good, it's good to surf, like this wrap-around-the-point left just inside the Gate.*

For centuries, the sea was the fastest way to see the world, and once our bay was seen, the world arrived. For trade, yes. For gold and silver, yes. For property and other tangible prospects, sure enough. But not only. You can manage a bank, own a restaurant, write poetry, and/or drive a cab a whole lot of other places, but in few other places can you gaze at an ocean quite like this.

From certain bluffs, you can watch the waves roll in and actually see the swells combine. Some are the short, thick remnants of a South Pacific storm; others, the choppy result of trade winds and a local breeze, both becoming together an inimitable shape, an exhausted force, one of an incessant succession of waves.

But we look the way we look not just because we are essentially "maritime." For one, we can see and feel the effects of the sea because we are steeped in hills. The fog clawing across the edge of a ridge is a favorite and fairly common image in the city. Luckily, however, the powerful forces that made these hills occur a little less frequently than either the waves or the fog. Just a few miles off our coast, America hits rock bottom—the Pacific tectonic plate over which we ride, at times violently, two centimeters to the southwest every year. And yet, the scenery around here is not only defined by what nature has done to and for us but what we have done to (and sometimes even for) nature.

Many an early visitor described San Francisco in much the same terms as Eliza

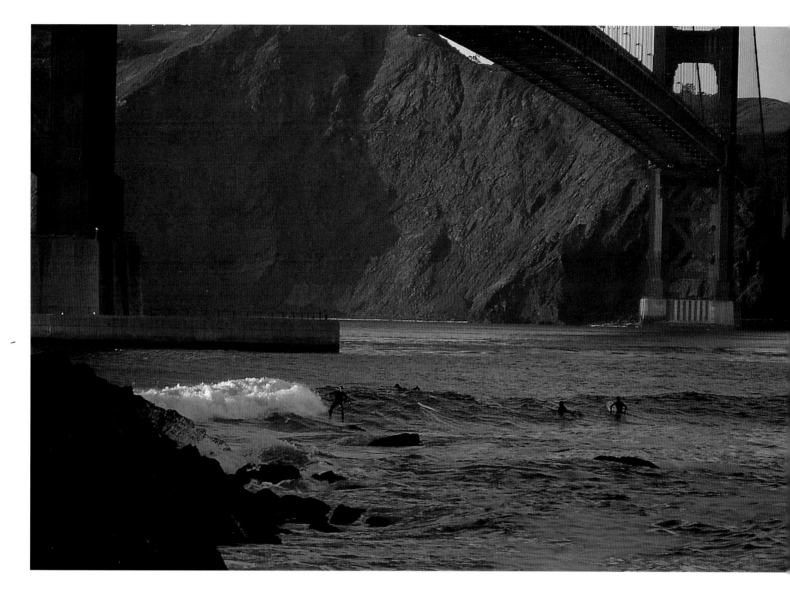

Farnham did in 1856. "San Francisco, I believe, has the most disagreeable climate and locality of any city on the globe." The winds blew hard and were filled with sand, that is, until San Francisco's civic leaders decided to contest the almost ceaseless intrusion of that truly western grit. Thus was born Golden Gate Park, a one-thousand-acre sand-suppresser. The sandy tendencies of the city have also been subdued by an amazing stretch of federal parklands, which, at least at present, include the hotly contested acres of the former army Presidio. Fairly untouched or at least green ecologies weave and rise around us, in part because the Golden Gate National Recreation Area controls over seventy-three thousand acres of land. In all, it comprises the world's largest

urban parkland. The grass- and sage-covered bluffs of the Marin Headlands, the oak and eucalyptus slopes of Mount San Bruno, and the whole coastline from San Francisco's southwest corner around and through the Golden Gate and all the way to Ghirardelli Square are protected environments.

More than just vistas and verdure, however, our "scenic seen" challenges the native to get out and do things. The truly adventurous jump off cliffs and hang-glide above the surf at Fort Funston. Others, at least equally insane, surf the big, smooth-faced winter sets at Sloats or shoot the channel over to the Headlands on sailboards during the almost daily gales of summer. There are intrepid hikers and bikers and skateboard riders who do their athletic thing

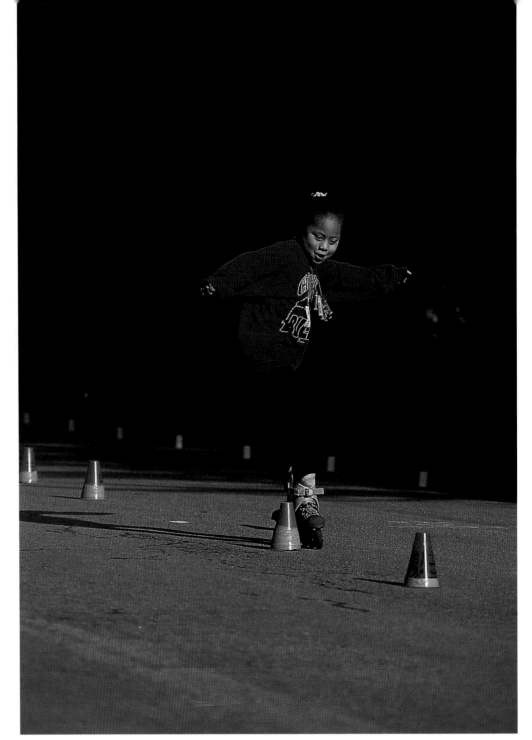

all over the slopes of Slant City. Others golf or stroll, fly kites or duff their duds to worship the sun *au naturel* on a few certain and secluded beaches. Truly, the "nature" of things in San Francisco is as varied and rich as its human cultures. Nonetheless, people—fourteen million plus a year—don't visit just because of the cliffs, the sea, and the trees. This is, first and foremost, a city. In fact, with a certain off-handed pretense, we often refer to our place not as the tetrasyllabic "San Francisco" but simply as "The City." Forget—or ignore—the fact that our population only comprises 12 percent of the whole Bay Area's

and that the whole Bay Area is only the country's fifth-largest metropolitan area. We ARE "The City" and have built ourselves accordingly. Victorian mansions, Edwardian palaces, hyperbolic parabola, and a pyramid or two—we're nothing if not extravagantly varied and often very extravagant.

Examples? Yes, ladies and gentlemen, and ample. Indulge me this "word-wind" tour of some of the best, though not necessarily best-known, places to see our scene.

Let's begin where things are BIG. Arguably the best place to see this riot of man-made and varied forms is from

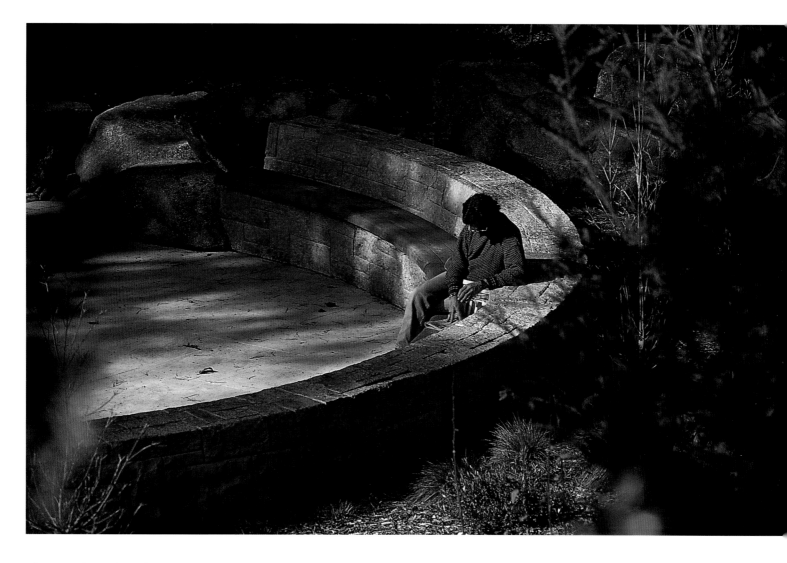

the Esplanade of the Yerba Buena Center. Take a seat on one of the two long wooden benches, or better, on the fountain-side curb, and watch the architectural show. From this vantage, the coincidental jumble of urban shapes is a post-modern Oz. Foreground and background, detail and sweep, the colors, the shapes, the textures, (not to mention the history) are layered in snug propinquity as if frozen in the movements of some gargantuan dance.

Look to the right and you will see, peeking above the low-slung corrugations of the new Center for the Arts, the Palace Hotel—in 1875, the "roomiest" hotel in the States. To the right, our new Museum of Modern Art—Mario Botta's bold design in which you can walk across (if you've got the stomach) San Francisco's third-most-stunning bridge. The bold simplicity of Botta's museum

is like a brick trampoline from which the up-stretching forms of the Pacific Bell Building leap into the eastern sky. (And speaking of leaping, check out the pair of concrete eagles poised at the roofline.)

Move the eye slowly back to the middle of the view—past the perspectively stacked forms of the 111 Sutter Building (the roof-line of a French chateau atop a twenty-six-story building!?!), the dull undulations of the Schwab Building, and the windowless tip of the Transamerica Pyramid.

Centerstage. And there, crouching ... what's this? A Pacific Gas and Electric substation??? Yes, (that is, until it becomes the new Jewish Museum), and the most

FOLLOWING PAGES: *Where there are open spaces and the possibility of people eating French fries, like here at the fountains near the bandstand in Golden Gate Park, you will find that attractive—though annoying—maritime marauder, the hungry sea gull.*

27

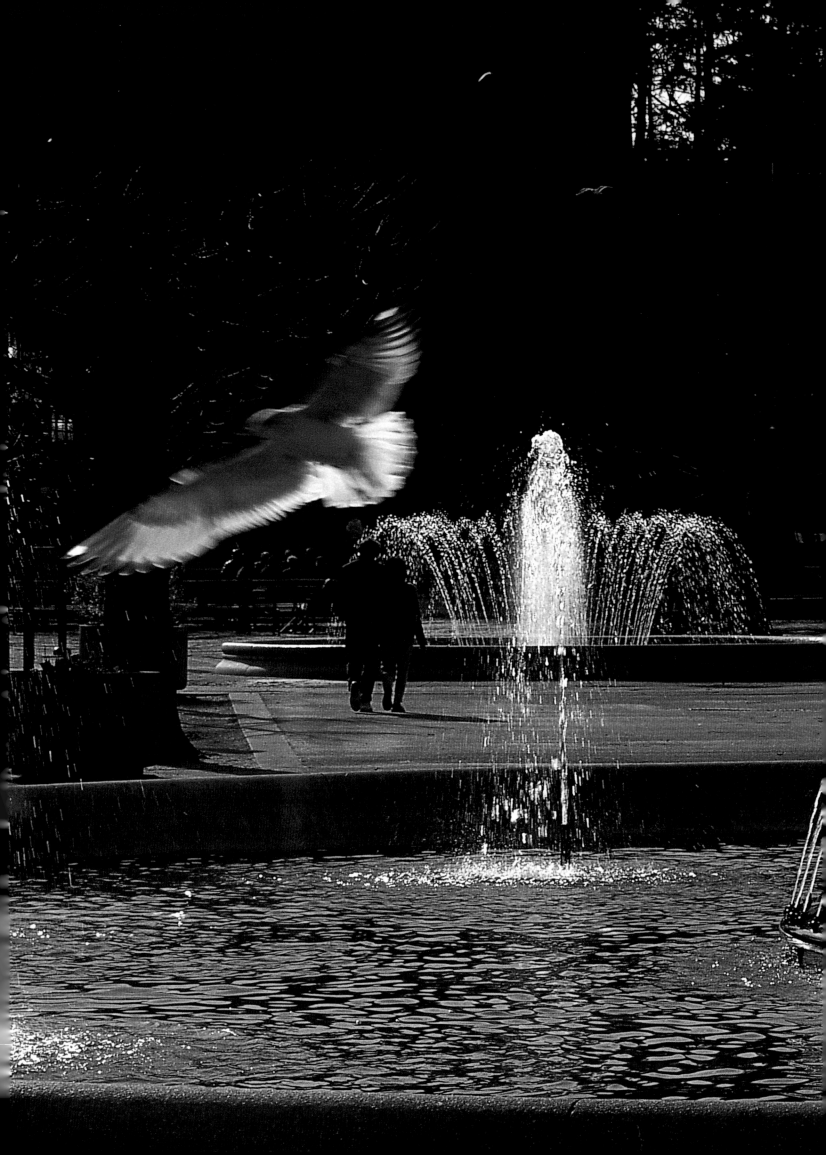

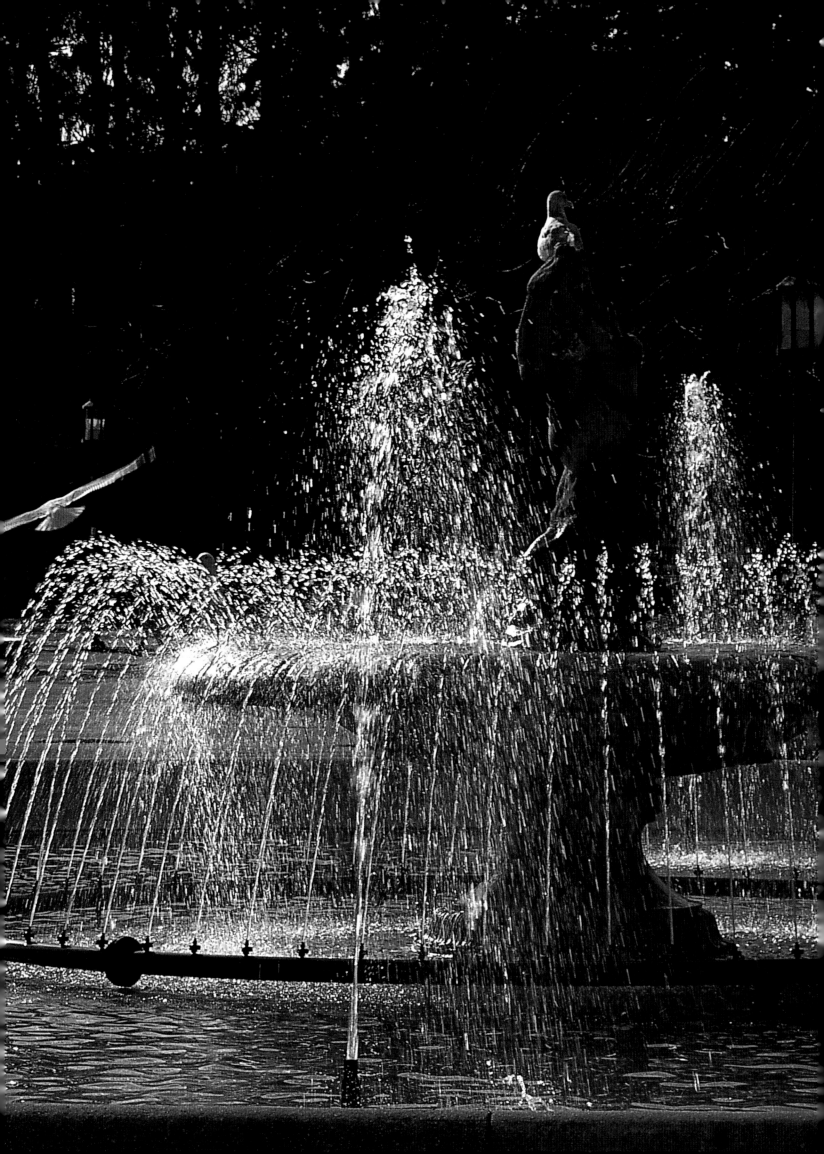

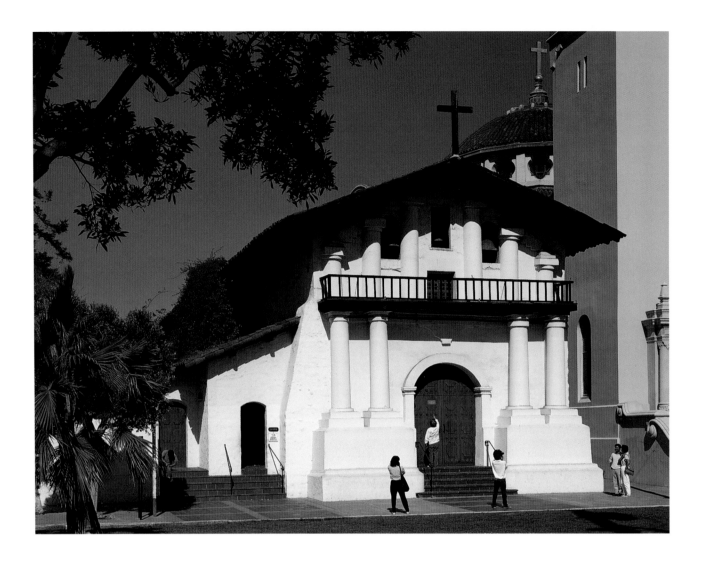

beautiful P. G. and E. substation you are ever likely to see. The artful arrangement of arches and windows on the face of this otherwise dull brick box makes it one of the most attractive places to rest the eye.

Ah, but the eye can't rest for long. It's hard to miss the visual struggle going on just to the left. There, the relatively small, elegantly symmetrical Saint Patrick's church does battle with the very large, asymmetrically brash Marriot Hotel just twenty feet to the west. Is Saint Patrick's diminished in the contest? Not in the least. In fact, were it not for the contrast, it would—for most of us— simply be "another kind of small, nice looking church." But there it is, a David made by a contextual Goliath. Frankly, I do not hold with the local pundits who suggest this Goliath "hath no charm." Yes, it is a bit like a large "Wurlitzer" or a set of gigantic "parking

meters"—but it also dances like a geyser and actually plays with the eye like few of our more "stately scrapers" can.

Speaking of play, the Yerba Buena Center is a great place not just for watching buildings. It is also an increasingly great place from which to watch people. This is our *Place Beaubourg*: this, the place of meetings and strange performances (the last time I was there, I watched a fellow who was doing loud, clever, and private battle with the Devil); this, the place for groups of wide-eyed tourists; hand-holding couples; families with kids, many of whom tumble on the grassy knolls or chase up and down the ramps; and, if you get there early enough, the solitary business woman sipping an espresso before she walks into and is consumed—for the day—by that huge and sweeping backdrop.

Next, ladies and gentlemen, another inimitable scene—this one on a more intimate scale.

I take you to my favorite sitting place in Chinatown, Hang Ah Street (AKA Pagoda Street). Relatively untraveled (there's little here for a tourist to buy), this is where people live and work and hang their *bok choy* on the fence around a tennis court.

"Hang their what?" you ask.

Bok choy, the staple green of Chinese cuisine, set to dry in family patches on links of a hurricane fence. It is supposed to "help the digestion" when drunk in a form of tea. On tables that line this rarely used tennis court, chess, mah jongg, and thirteen card are often played on warm mornings. Laundry and teapots hang from windows. The old brick buildings are muralled with new art or ancient, fading, and obscure advertisements. There's a tea-room, the Kong Fun Club (closed during the day), an insurance broker, the Buddhist Propagation Center, and in the middle distance to the east, the Pyramid—almost benevolent and seemingly ubiquitous.

Let's now hop or, rather, climb across town. Here is the more classically "scenic" as seen from the flanks of Buena Vista Park, three hundred and sixty degrees of "The City," one of the highest summits in town, and from time to time, the eyrie to a pair of red-tailed hawks.

FACING PAGE: *The oldest intact building in San Francisco is the Mission Dolores. Here the Camino Real—the Spanish "Kings Road"—came to its northern end. Here also lie the remains of over five thousand Ohlone Indians who succumbed while under the "civilizing" influence of Western culture.* BELOW: *The first semi-permanent tent, the first somewhat more permanent house, the first town plaza, the first American flag, the first saloon, and a whole lot of other firsts occurred here at Portsmouth Square, now in the heart of Chinatown.*

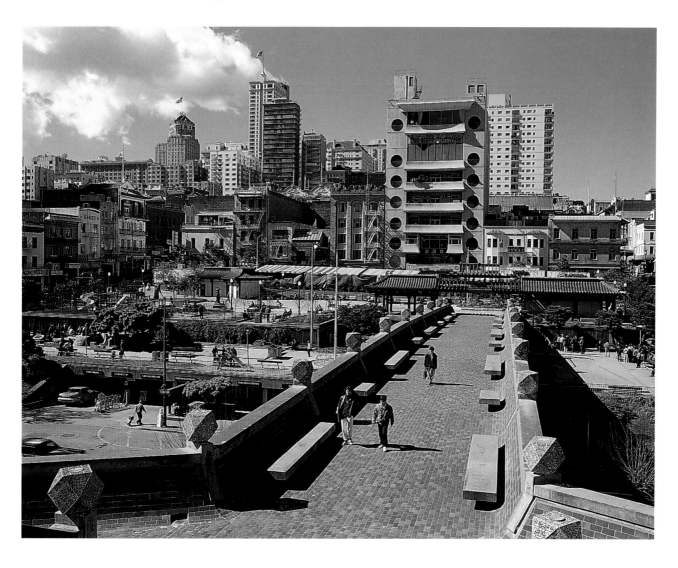

No wonder. From here, everything is visible: Hunter's Point and the Mission; Angel Island and the recumbent Tamalpais (vertical in view, horizontal in myth); the Golden Gate Park and the Sunset and the Farallon Islands peaking at the edge; downtown, the East Bay, and the Bay Bridge that connects them.

A quick look at the park is worth the while as well. Only a few blocks from Golden Gate Park, this 36.5 acres of steep greenery was designed and, to a great extent, planted by San Francisco's master gardener, John McLaren. This is a park "on the wild side"—and not just because it is between the Haight and the Castro. Too steep for traditional landscaping, the trees are huge and planted thick. The most transporting time to see all of this is early in the morning or late in the afternoon when the sun and/or fog weave and slant through this large, quiet arbor.

Finally, let's check out one more aspect of the "scene." This is a place where things are still happening, more than two hundred years after the *Camino Real* (the "King's Road" that was built to link most of Alta California's missions) came to its most northern, most far flung, and perhaps even most "far out" end.

It doesn't get much more vibrant than in and around New Bohemia, "Villa" Valencia Street in the Mission District. This is where many of the younger and/or single and/or somewhat more daring gather to do their things.

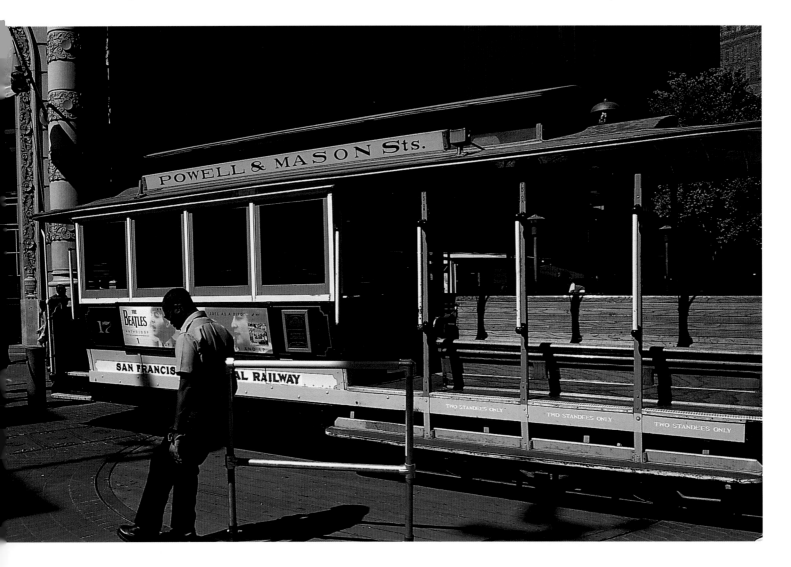

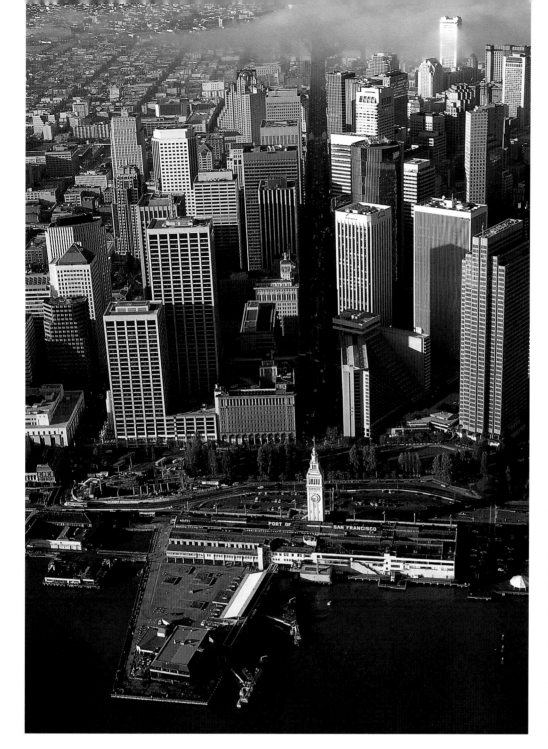

FACING PAGE: *Part of the attraction has to be the human side—the bell ringing, brake pulling, cable gripping, turn-around turning—necessary to keep these, the oldest running cable cars in the world, still running.* LEFT: *With the removal of the Embarcadero Freeway after the 1989 earthquake, the Ferry Building, constructed in 1898, was restored to its visual command at the base of Market Street.*

Were you to stand in the middle of Sixteenth Street mid-block between Valencia and Guerrero, you'd see proof positive that something is—or a whole lot of some-things are—happening here. A green awning announces "PRODUCTOS DEL NORTE CENTRO SUDAMERICA Y DEL CARIBE TODO PARA EL SABOR"—and what truly "savorous" delicacies they are. On the other side of the street (and packed like individually labeled sardines) is a unique threesome, "Lee Hong Hairstyling," "Truly Mediterranean Falafel," and "Grande Ho's Hibache," (a Korean and Thai restaurant)—and all this next to the Roxie Cinema (don't forget to pick up this month's film schedule—you don't want to miss the Bela Tarr Tribute including "Prefab People," the James Dean retrospective, "Lilith," "Gay Cuba," "The Baby of Macon," and the best from the recent Hong Kong Film Festival).

If you haven't been hit by the traffic yet, turn to the right and see the Club Albion where some very hot—and very not—music

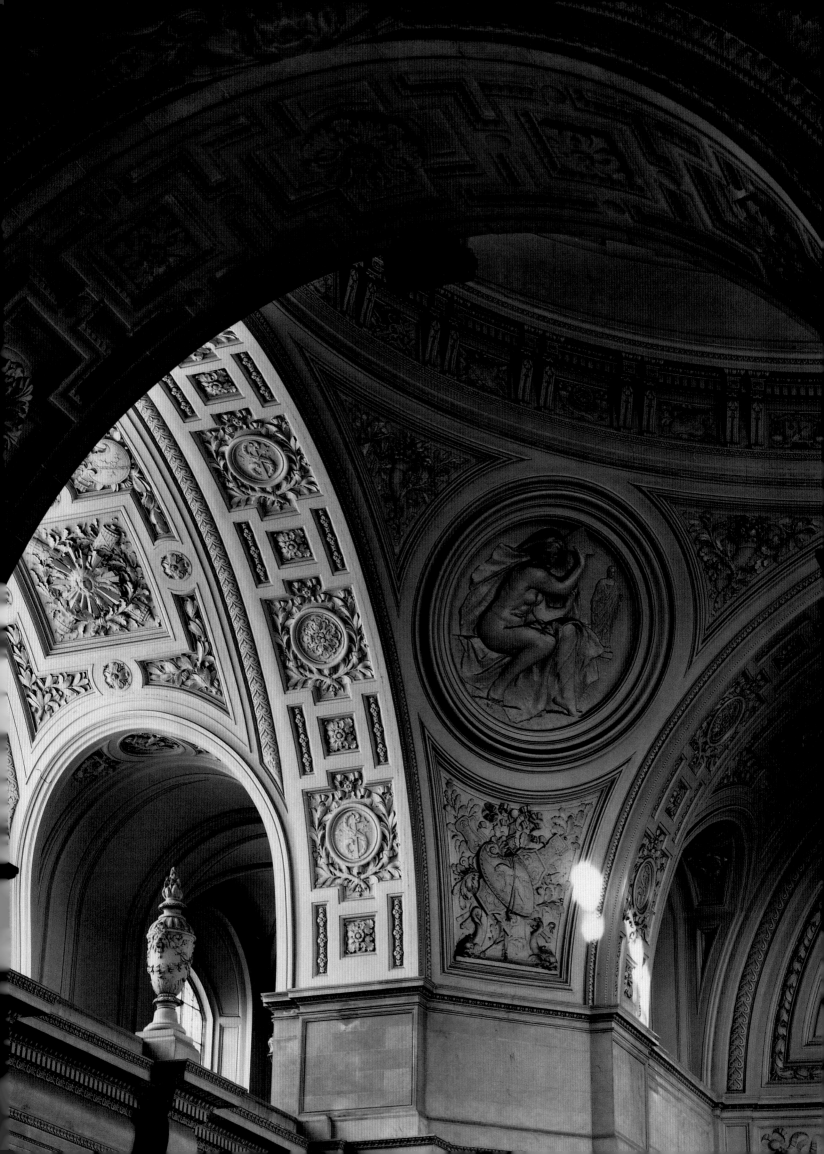

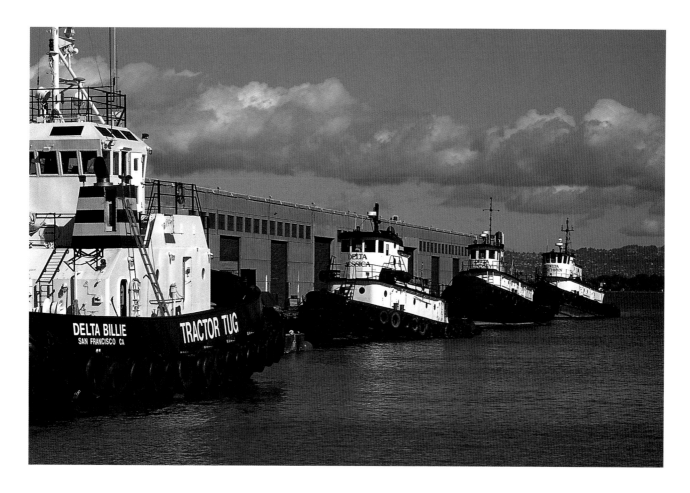

gets a live start, then quickly turn around and check out "The Kilowatt" (soon appearing: The Motards, Cry'n Out Louds, The Tripjes, and Loli and the Chones).

Had we but time, we could amble on down to Valencia Street, turn right, and poke our heads in La Cumbre (still the best *asada* burrito in town—thanks to the salsa), walk past the Istanbul Cafe (the olfactory atmosphere alone is worth a sniff), the Indian Bazaar (full of all manner of Subcontinental food stuffs and other stuffs), the Chameleon Room (Psycho Betty, coming soon), the Iglesia Beta (*Casa de Dios, Puerta de Cielo*), and finally circle around to the Mission itself, the Franciscan reason this city exists in the first place.

I leave you here—hopefully not still in the middle of Sixteenth Street—simply with a bit of advice. When going anywhere in San Francisco, get out of the car or taxi,

take the trolley or ride the cable car to the end of a line—any line, then start walking in the OPPOSITE direction from the people with the cameras. Buy the postcards, if you must, but get out and see some of the rest of the "scene." This is, perhaps, the only city in the world where you can't go wrong. After all, as one television director recently remarked when asked why San Francisco was a good place to shoot pictures, "There are no bad angles."

FACING PAGE: *Layers of recollection; the Beaux Arts Design of City Hall was meant to suggest St. Peter's Basilica which itself suggests various Roman precedents.* ABOVE: *The first permanent house in San Francisco, called the Old Adobe, was constructed by William Richardson. A British sailor who jumped ship in 1835 to become the city's first harbor-master, Richardson is a long-lost colleague to the captains of these tugs.* FOLLOWING PAGES: *With only about seven hundred thousand inhabitants, San Francisco is not a huge city. It is, however, THE hub of the Bay Area, and these trains at the SamTrans terminal await their evening fill of South Bay commuters.*

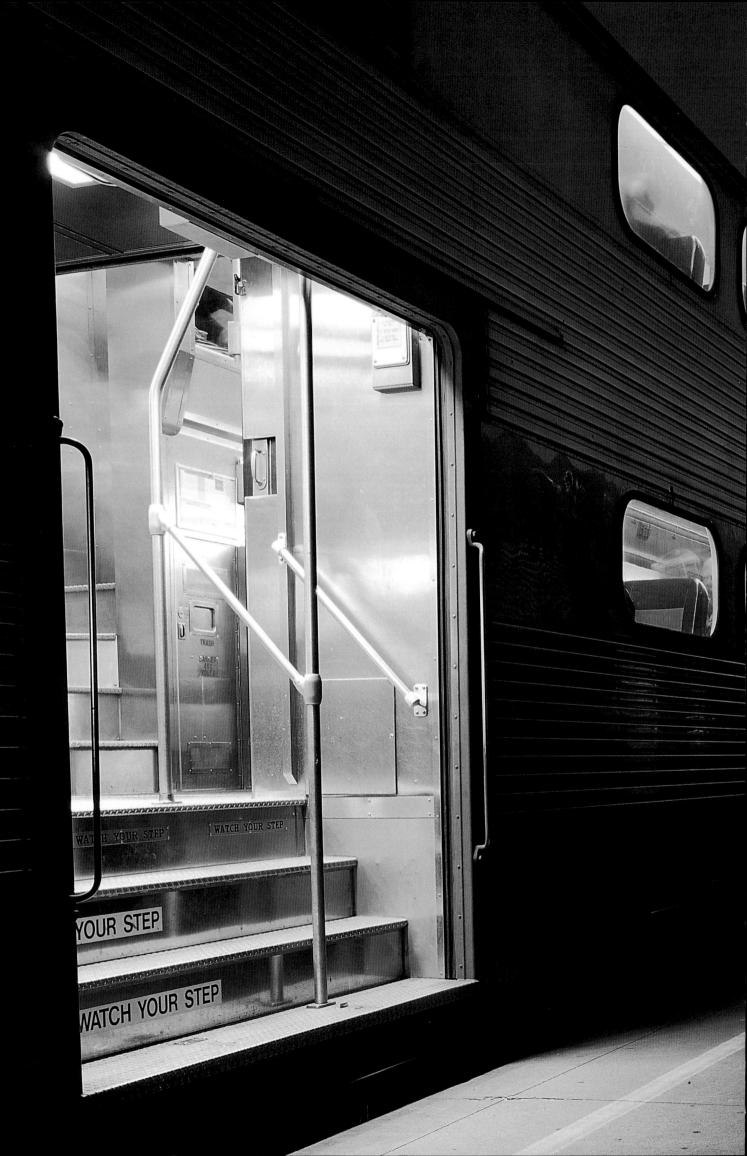

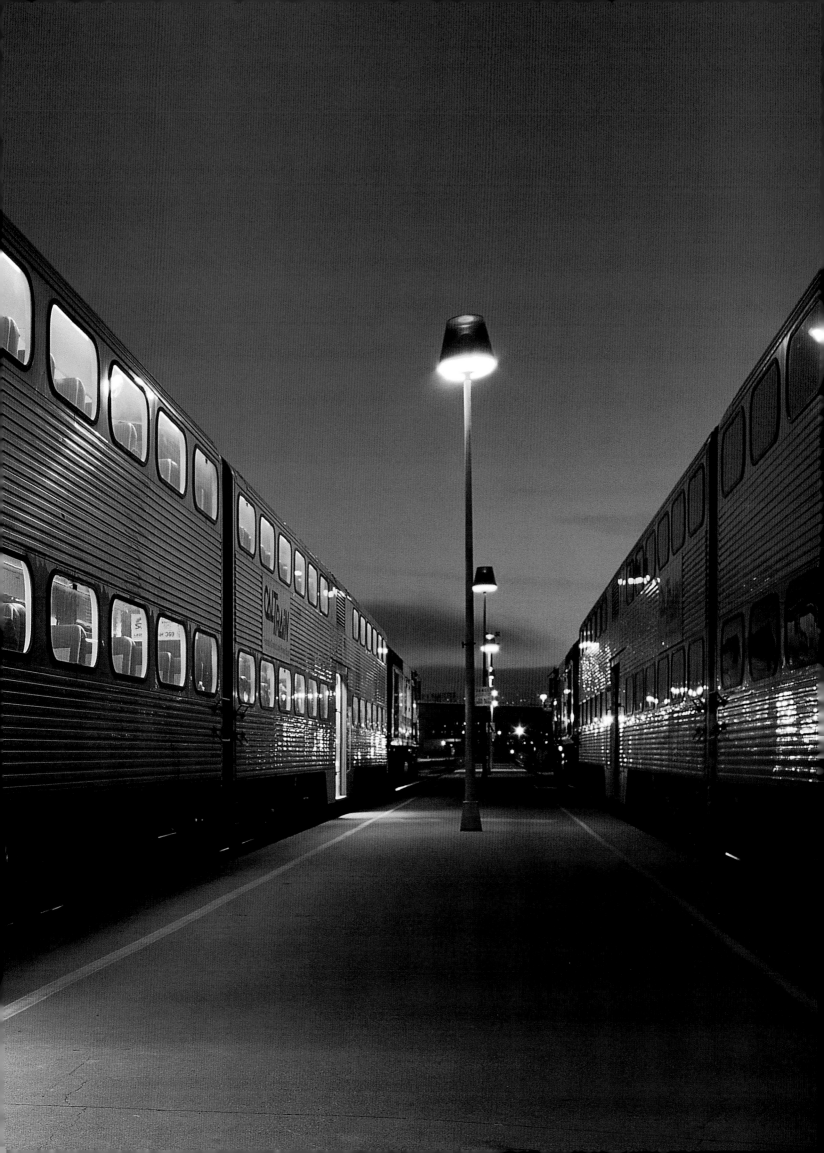

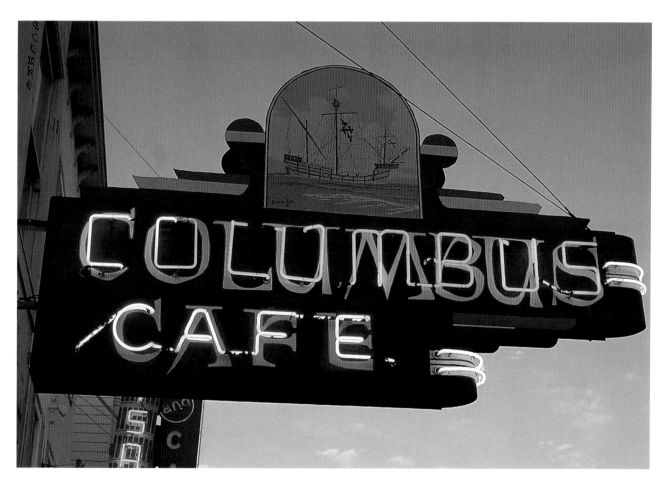

ABOVE AND FACING PAGE: *San Francisco, one of the most diverse cities in the United States, offers a wide selection of delectably* *diverse nighttime activities—ranging all the way from the good through the weird to the wild.*

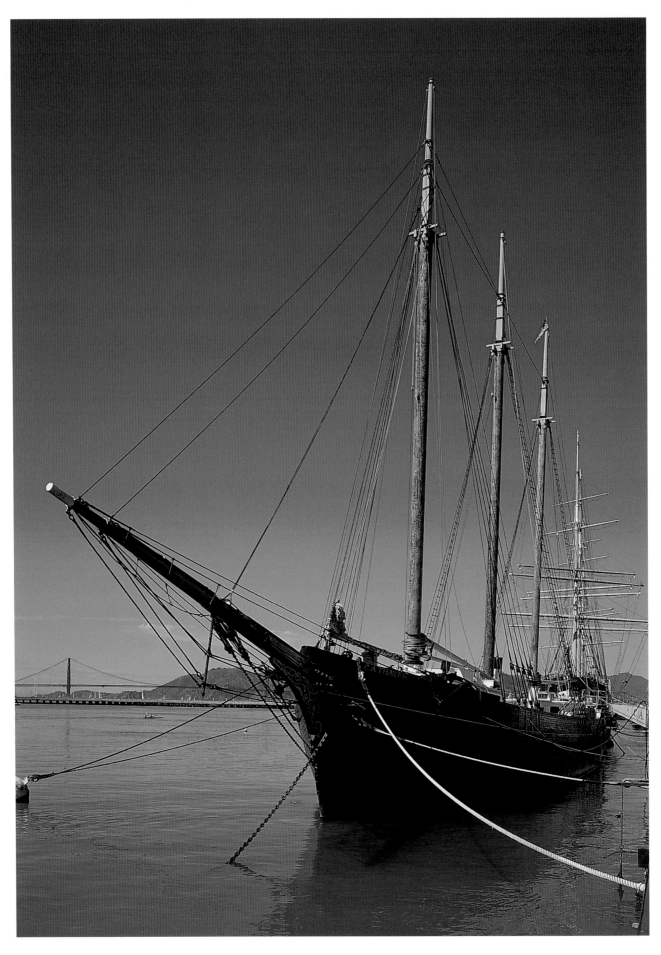

ABOVE: *Now but isolated reminders, tall ships moored at Aquatic Park recall an era when up to six hundred sailing ships crowded our wharves.*

FACING PAGE: *One of the most evocative aspects of San Francisco is the juxtaposition of old and new forms, here seen along the Embarcadero.*

A Place in History

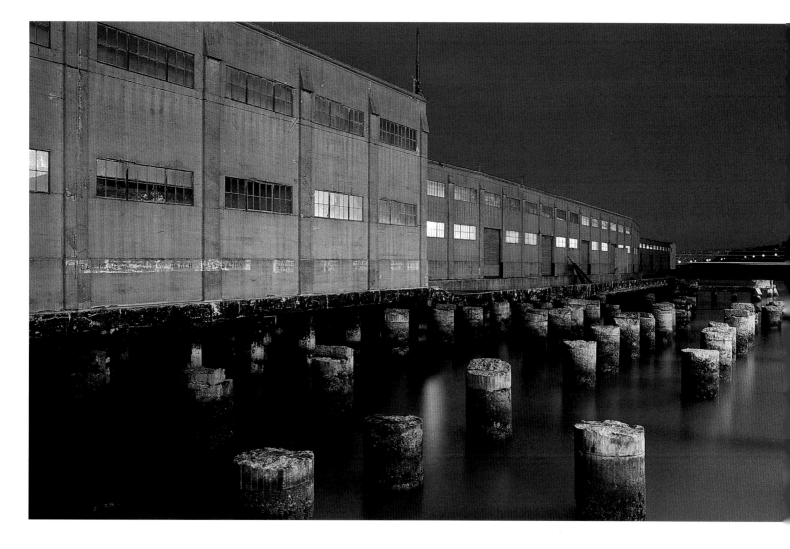

In a parallel though very different universe, San Francisco was born in the same year as the United States. Less than one week before, a certain gentleman from Boston literally gave his John Hancock to an uppity declaration, a group of almost equally daring souls declared their intention to raise a mission in honor of San Francisco (de Assisi) on the very far and other edge of the continent. New England would get its independence and Nova Albion (so named by Sir Francis Drake who careened his "Hinde" near Point Reyes, circa 1579) was being "reassigned."

Was the Spanish crown really all that interested in the tip of that windy peninsula? Not terribly. But the Spanish could sense a challenge. England was preoccupied with other American territories but the Russians posed a threat. Recently "discovered" by Gaspar de Portola (1769) and observed to be the best harbor in all of California, the Russians saw its potential for their fur trading purposes. So, Spain sent a motley group of about two hundred souls on a far-flung mission. Franciscan colonists and their small military escorts would bring Spanish culture and Catholic cosmology to the shores of the blustery bay.

Little of any of this was to prove terribly significant either to Spain or to the world. The Russians had neither the desire nor the naval prowess to have taken and

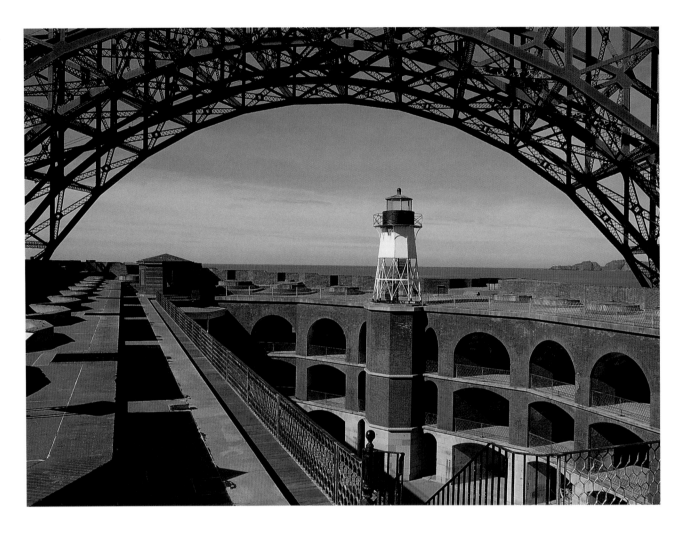

held San Francisco had it come to a fight. And the Spanish were themselves hard pressed to supply such a distant, unimportant outpost.

The town of Yerba Buena, later called San Francisco, remained a small sea-trading outpost while the reins of power were transferred from Spain to the independent Mexico in 1821. The Californios, as the local residents were called, traded little more than hides and tallow to the various ships that plied the coast. In fact, the first permanent structure on the cove itself was not built until 1836, and that was but a four-posted sail-wrapped affair belonging to William Richardson. This former English sailor

who "left his ship" and married the mayor's daughter, became the first harbor master and informal customs official for the slowly growing port.

Indeed, it was a small, barely inhabited place back in the early nineteenth century. As Steve Richardson, William's son, wrote, "I often used to sit on the verandah of my father's house and watch bears, wolves, and coyotes quarreling over their prey along what is now Montgomery Street." That everything seemed to change as soon as gold was discovered near San Francisco should not suggest that the seeds of change had not, by then, been carefully planted. America had been anxious to get its hands on the West

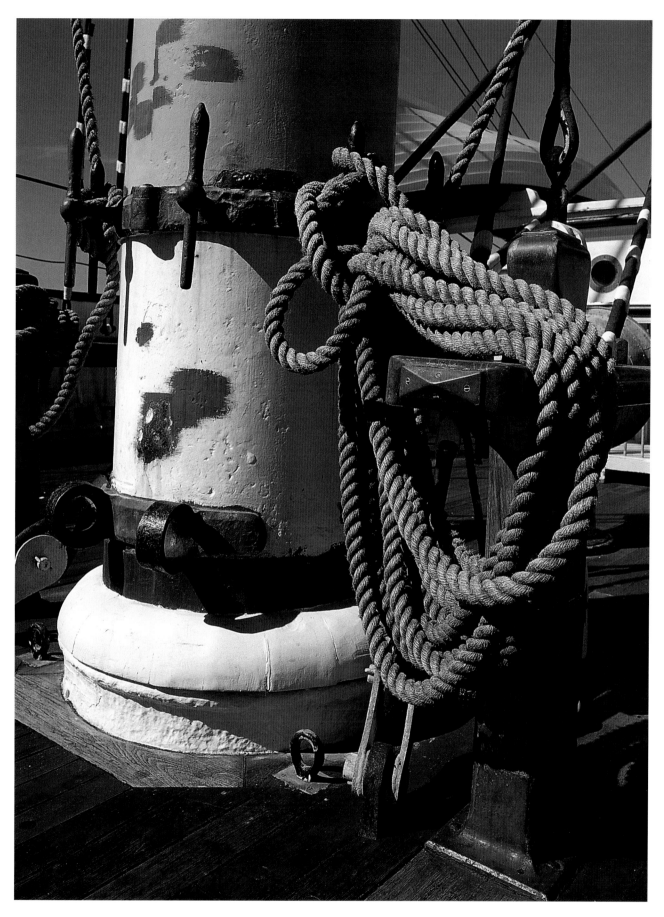

FACING PAGE: *Although built to defend the city, Fort Point has never needed to fire its guns at an intruder.* ABOVE: *Belaying pins and manila line recall a hearty time when a trip to San Francisco often meant braving the seas to get there.* FOLLOWING PAGES: *The panorama from the esplanade at the Yerba Buena Center includes, to the east, the daring masonry of the new Museum of Modern Art.*

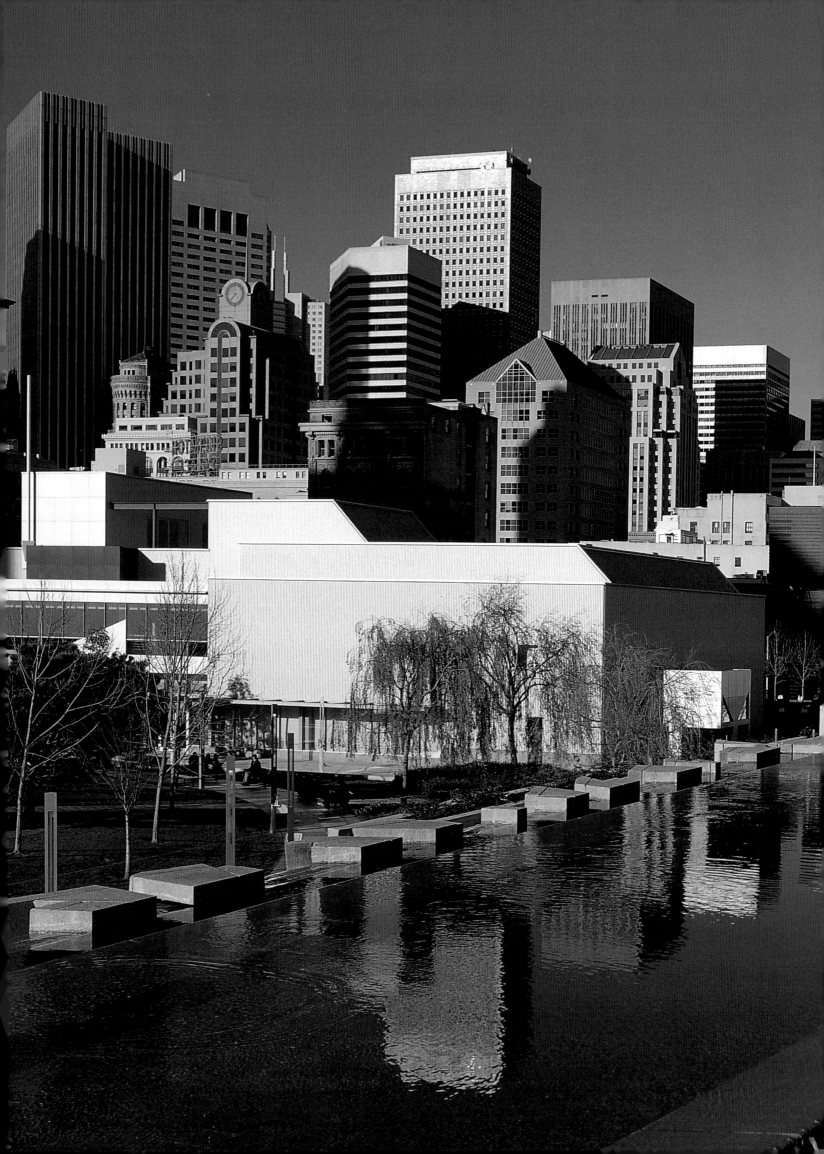

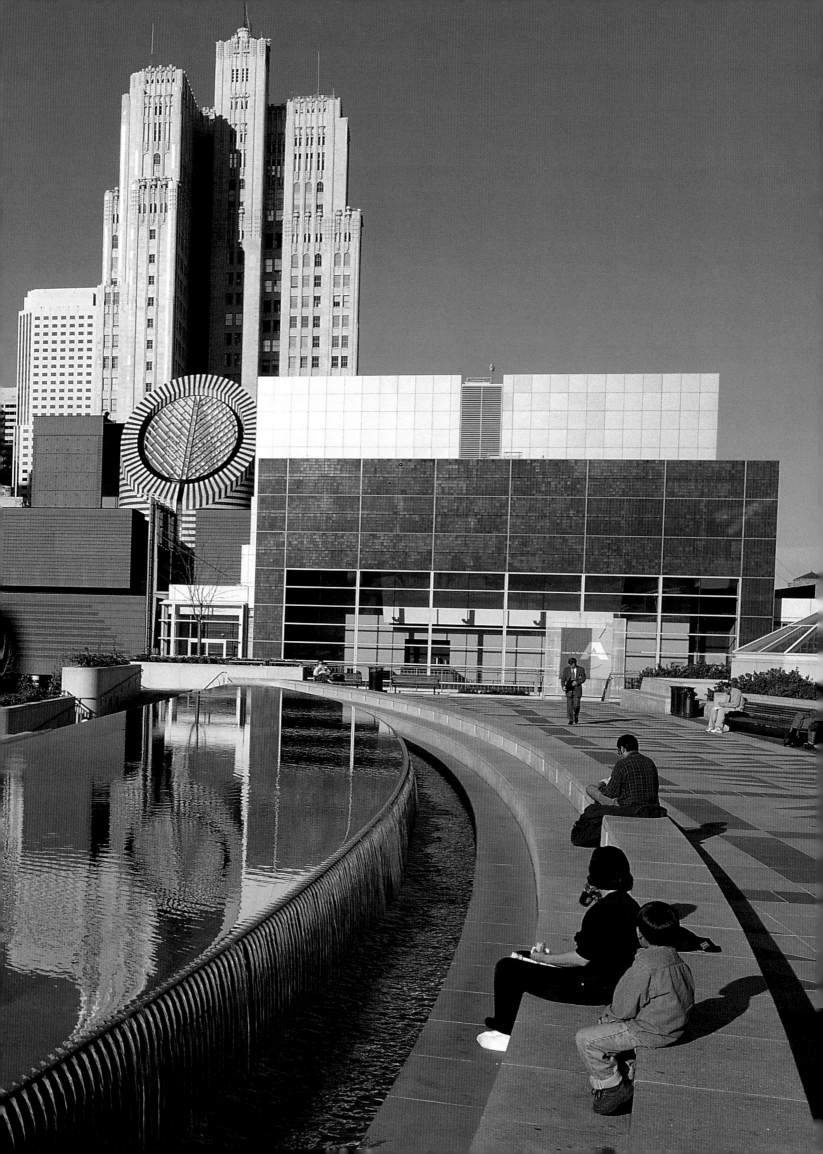

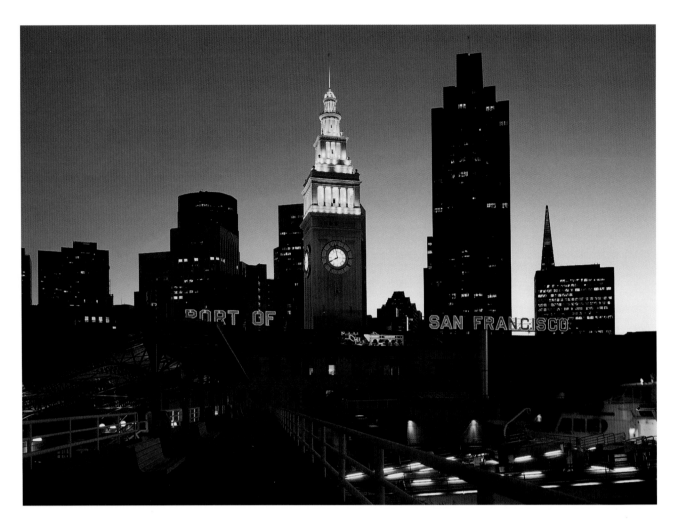

Coast for some time. It seemed "our Manifest Destiny to overspread and to possess the whole of the continent ... for the development of the great experiment of liberty and federated self-government," so, at least, it was stated in *The Democratic Review* in 1845. The idea of possessing California and its Pacific shore was downright (and low-down) attractive. Kit Carson and John C. Frémont, sent by the U.S. government on a "scientific" expedition, were caught lugging a military howitzer across the Sierras in the early 1840s. We can only suppose that science was a more dangerous endeavor at the time.

In an ironic twist, the lopsided Treaty of Guadalupe Hidalgo that ceded California to the United States was signed nine days AFTER a gringo discovered "El Dorado" at Sutter's Mill. It wasn't until a few months later that that discovery became fairly

common knowledge, and then, it was too late for anybody to do anything about it— except, maybe, grab a shovel and rush out to see how much could be grabbed. Clearly this is an example when, in the lives of cities, fate favors those in the right place at the right time. Various sites in the East Bay would probably have been more convenient as a springboard to and from the Sierra foothills. Sacramento would have been a better place to weigh in and spend the loot had the Sierras not intervened to make the East so much further than it seemed on a map. And so, the place with the wharves (albeit, few and poorly built), a few storage sheds, a fairly useless fort, and a few hundred people became the quintessential American boomtown.

The vast and rapid changes that occurred then have been well rehearsed: the one hundred thousand plus people who

came to California, most of them through San Francisco, in one year alone; the eight hundred ships that, in one year, left New York bound for 'Frisco; the three hundred ships abandoned by their gold-seeking crews (the hulls often becoming part of the landfills upon which much of downtown has been built).

What is less well rehearsed have been the effects of this rush upon the history of America. For one, the western movement—good, bad, or indifferent—occurred faster than it would have otherwise. No graceful transition from the ranchos to real estate. Whatever could be taken and sold was—usually as quickly as possible. Even the term *Nouveau Riches* suggests too much stability. We were the "instant rich" or, since not quite *all* became instant millionaires, we could, at least, be classed as "energetic opportunists."

Levi Strauss came to make canvas tents and wagon covers but ended up riveting some very popular jeans. The Big Four—Hopkins, Stanford, Crocker, and Huntington—seized the opportunity to help a cash-starved and warring government complete a railroad. The riches of the west—delivered more quickly by rail—were expected to help the Union. That the railroad wasn't actually completed until 1869—well after the war was over—didn't keep the Big Four from making a tidy (transcontinental) fortune.

The other significant effect was the rapidity with which San Francisco and the golden foothills not far away became a destination for people coming from the west (that is to say, the East). Many of the first prospectors were Kanakas from Hawaii and Marquesans from Polynesia who came to San Francisco by the thousand. The

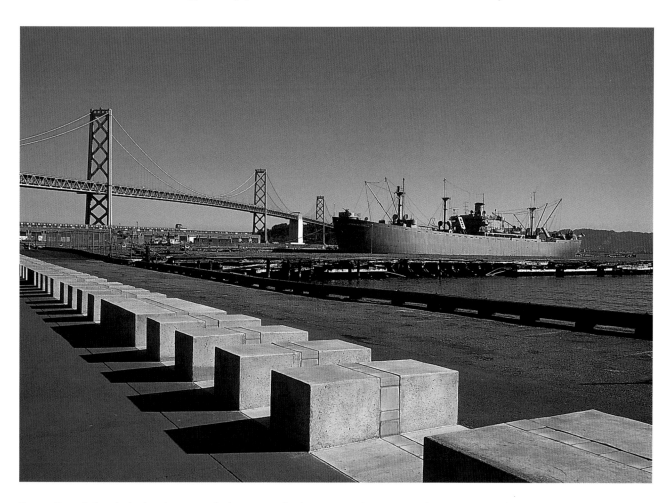

FACING PAGE: *Before the bridge, there was only the Bay—and only a boat could get you across it; hence, the importance of the Ferry Building* as the gateway to the east. ABOVE: *After the destruction of Pearl Harbor, San Francisco Bay became the West Coast's largest naval port.*

most significant eastward migration came, however, from Guangdon Province in China, the only province at the time open to trade with foreign powers. San Francisco, in fact, became known in Cantonese as *"Gum sahn dai fow"*—Big City of the Golden Mountains.

Gold was not, however, the only thing that attracted many of the Chinese. Good thing, too, since there were many restrictions, both *de jure* and *de facto,* that prevented the Chinese from deriving much profit from their claims. No, what attracted many of the Chinese, and made their presence all the more attractive, was the work they could do in and around San Francisco. As quick as we are to decry the effects of too much immigration, we are even quicker to hire good cheap labor to do the work we, the "natives," would rather not do. And this they did. "Crocker's Pets," as the Chinese railroad workers were derisively called, dug through and around the Sierras better than any group of workers available. And that was just the beginning of the immeasurable contributions at all levels of our culture made by those who "went east" while others were going west.

Gold caused the rush but silver made us rise. By the late 1850s, our rip-roaring town was beginning to settle down a little too quickly. Waning were the days when the boys would toss gold (coin or nugget) at the girls on stage. There was still growth but the boom was over until silver was found in the hills near Reno.

The Comstock Lode, discovered in 1859, was the largest lode of silver found anywhere in the world, and, in the next two decades, it generously poured over one billion dollars into or through San Francisco. But silver mining is not the same thing as gold mining. A lucky man with a pan can't do it.

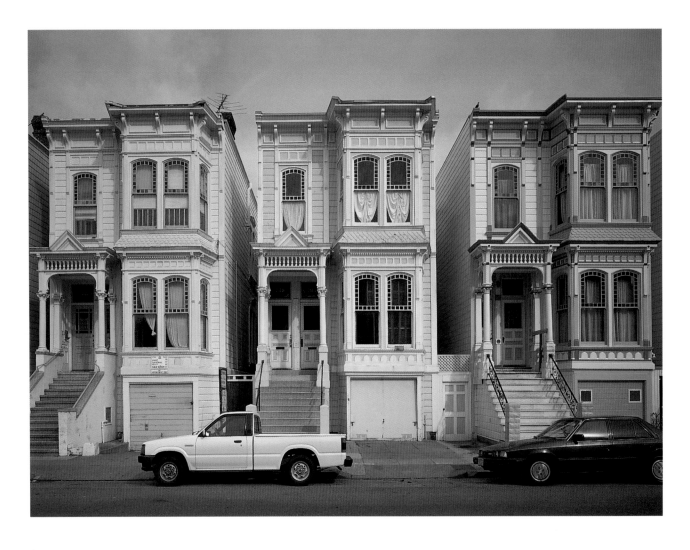

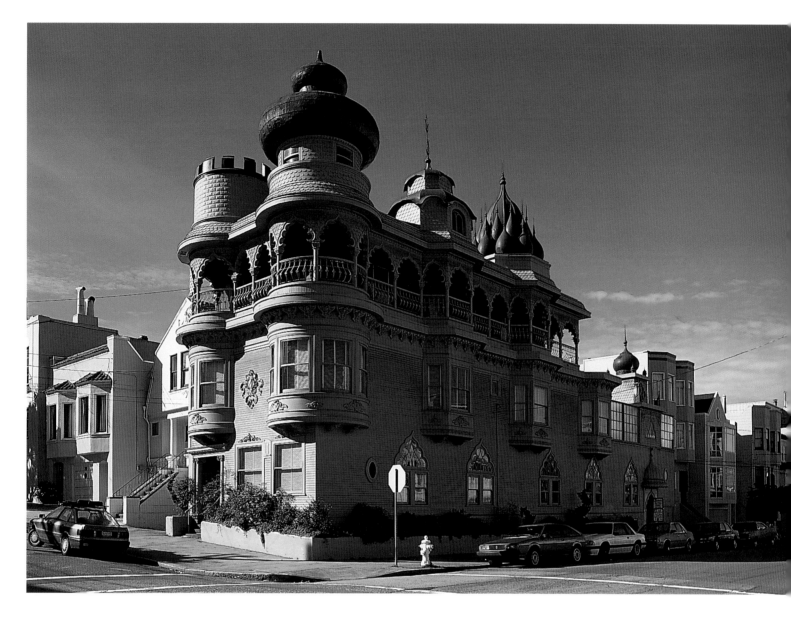

It has to be mined and refined and those processes required money to begin with ("adventure" capital might be the appropriate name). In much the same way that the Big Four gambled on a fairly abstract and complex investment and won themselves a railroad, so the Bonanza Kings (also four men) and investors like them gambled with abstract stakes and made huge, centralized profits. Like a shot of fertilizer after the first green appears, silver brought San Francisco to blossom—at least at the top of Nob Hill. (The only pre-quake house still standing at the top of the hill belonged to Bonanza King, James Flood.) Silver consolidated the West Coast wealth in San Francisco, and San Francisco didn't mind one bit.

First through the "golden time" and then through the time of silver, many a fellow swaggered, drank too much, connived, extorted, murdered, and/or saw too much of too few women. In essence, San Francisco raised hell while it raised itself a city. And when the suspect services of the local authorities weren't enough, some of the rougher elements were "put down" by equally rough vigilantes. In the clearest terms was it written, "WARNING, NOTICE IS GIVEN that any person found pilfering, stealing,

FACING PAGE: *Victorian houses come in a number of distinct "flavors." This row of flats is typical of the Eastlake, or Stick, style, known for its rectilinear massings and embellishments.*
ABOVE: *And then, there are the Victorians of no clear flavor at all, like this hulking hybrid resplendent with Queen Anne windows, Moorish tracery, and medieval crenellations.*

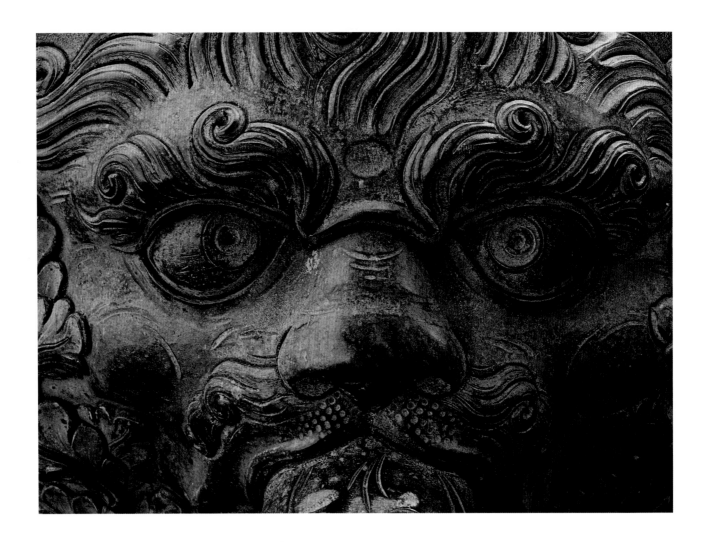

ABOVE: *This bronze lion is a detail on a French "24 Pounder" cannon on display at the Presidio. It was captured from the French and later taken from the Spanish by the Americans. So goes the bronze booty of war.* FACING PAGE: *As the presence of this altar suggests, Fortune needs some nudging, even in San Francisco's first fortune cookie factory.* FOLLOWING PAGES: *With pride, San Francisco celebrates the Gay and Lesbian Day Parade one Saturday a year, but daily, there is both pride and a bit of a parade along Castro Street.*

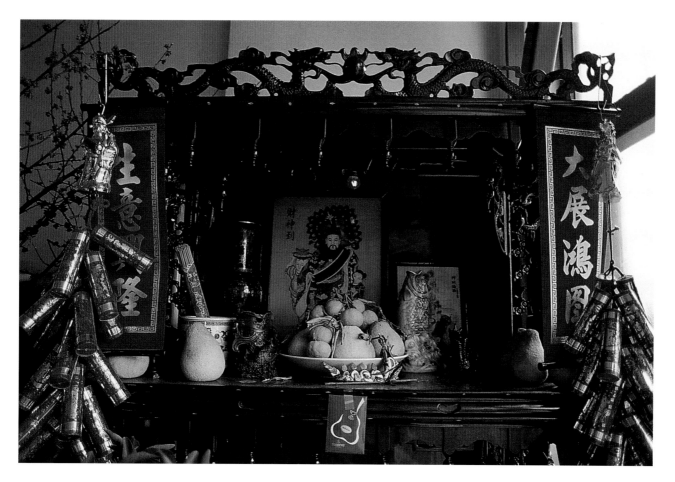

robbing or committing any act of Lawless Violence will be summarily HANGED."

During the nineteenth century, we went boom then bust then boom again. But through it all, with greater or lesser vigor, we continued to grow. By 1870, with a population of nearly 150 thousand, San Francisco was larger than Washington, D.C., Cleveland, and Detroit. Perhaps nothing better typifies this explosive show than the Victorian houses. Contrary to many of their prices now, these were not the abodes of the millionaires. These were the quick-built places of the middle class—the long, tall, and narrow boxes on the face of which you could show (or show off) what you thought you were worth. And you didn't need to be worth all that much to get some of California's then-abundant redwood tooled or turned into Italianate pilasters, Eastlake lines, or Queen Anne curves.

Change has come fast to San Francisco but never as fast as it did on the morning of April 18, 1906, when the ground turned to liquid and rolled in waves up to three feet high across the city.

A few of the facts and figures: the 1906 earthquake was thirty times stronger than the 1989 earthquake. More than five hundred tombstones fell over—all to the east. Two hundred fifty thousand people were left homeless. More than three thousand people lost their lives. And the fires that raged for three days consumed roughly twenty-eight thousand buildings. Not all buildings in the path of the fire were destroyed, however. A notable example is the Hotaling Building in the beautifully historic Jackson Square district. Among other things, at the time, it was a warehouse of some rather expensive though highly flammable liquids. The irony

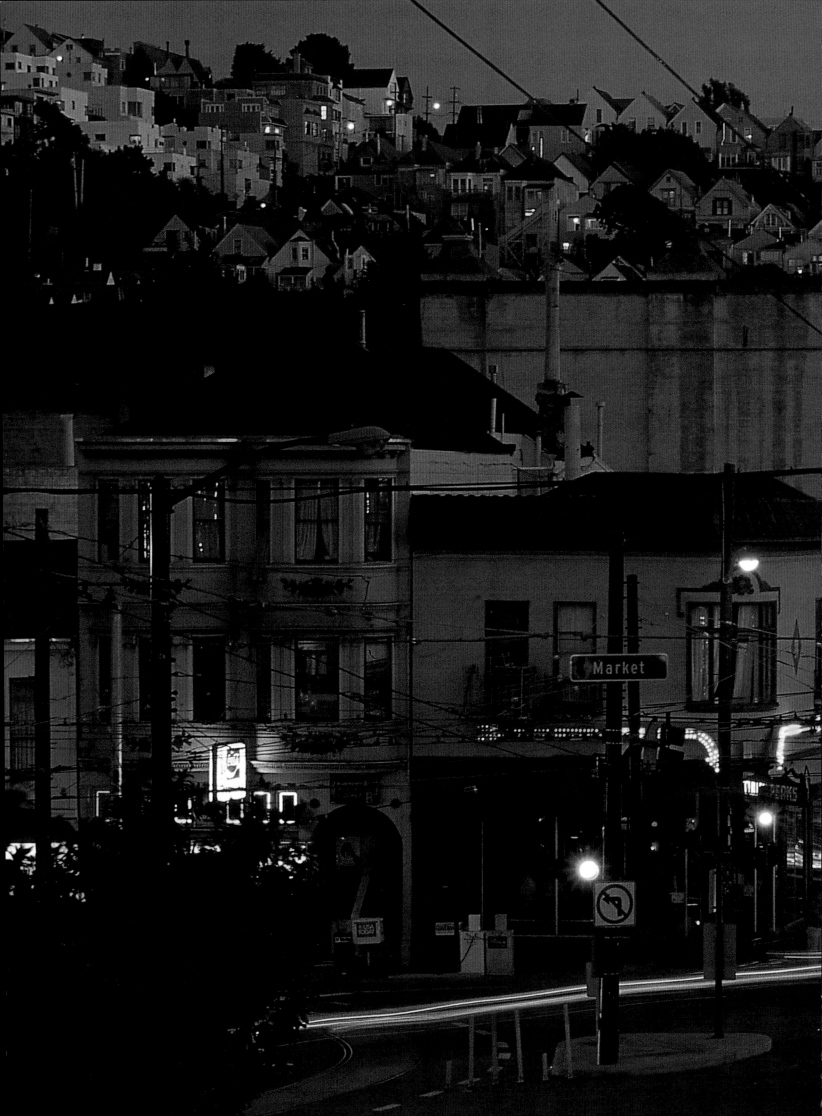

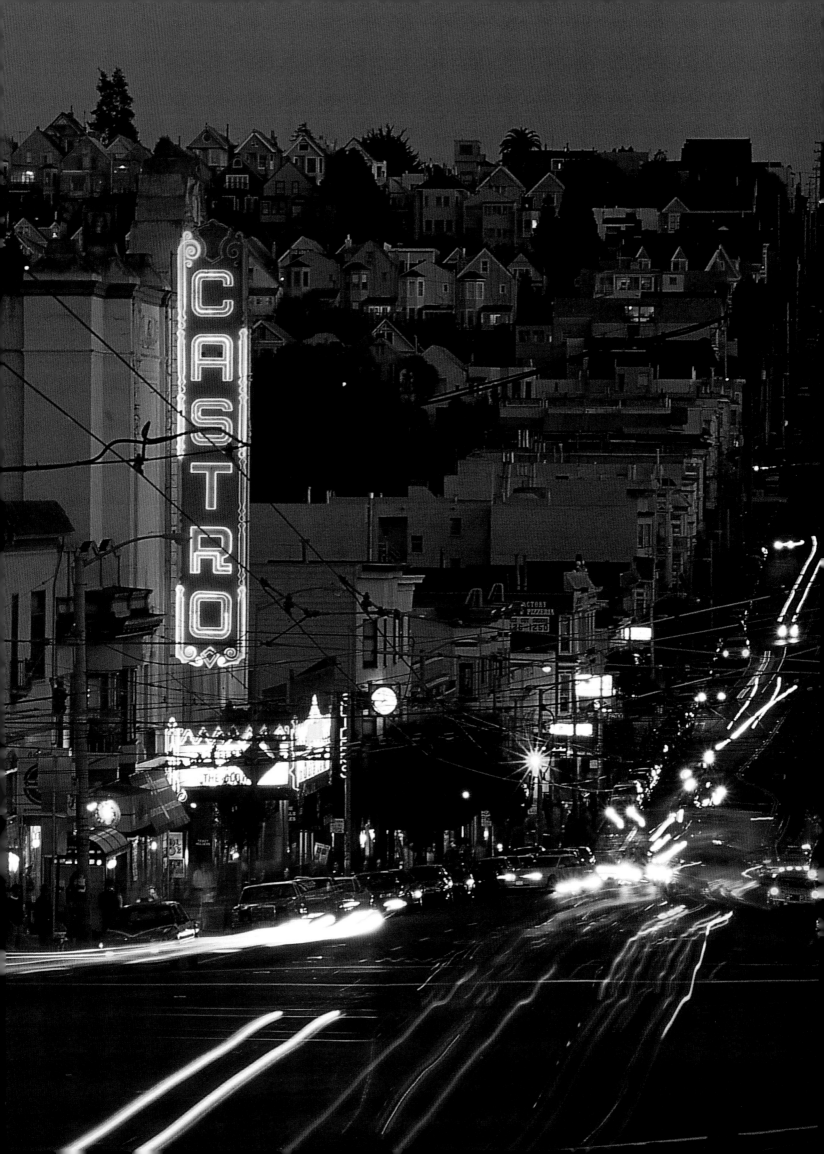

occasioned a bit of clever wit, "If, as they say, God spanked the town for being over frisky, why did he burn the churches down and spare Hotaling's Whiskey?"

More than anything else, however, the 1906 earthquake is a lesson in functional eschatology. The 8.3 jolt along the San Andreas fault did more than occasion some urban renewal. We went through an entire cycle—birth, death, and rebirth. The mansions at the top of the hill and the tenements at the bottom alike were knocked askew and then burned. The scope of both the damage and the effort to rebuild San Francisco is unrivaled in U.S. history. Yet, rebuild we

did—almost (again) instantly. The Victorian era was over. We were renewed from the ground up in a new era—a new century. The very well `attended Panama-Pacific International Exhibition in 1915 achieved a good measure of its intended effect. That Fairground glorification of transport and commerce and all those other good things that a long and deep ditch can bring showed the world that San Francisco was back.

It may, indeed, be this desire to show that we are back that has, in some senses, kept us "back." There is something necessarily conservative (an ironic term to use in this otherwise UNconservative place),

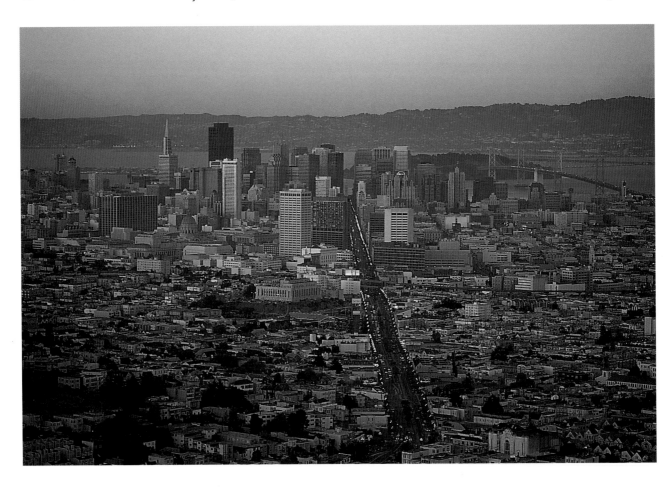

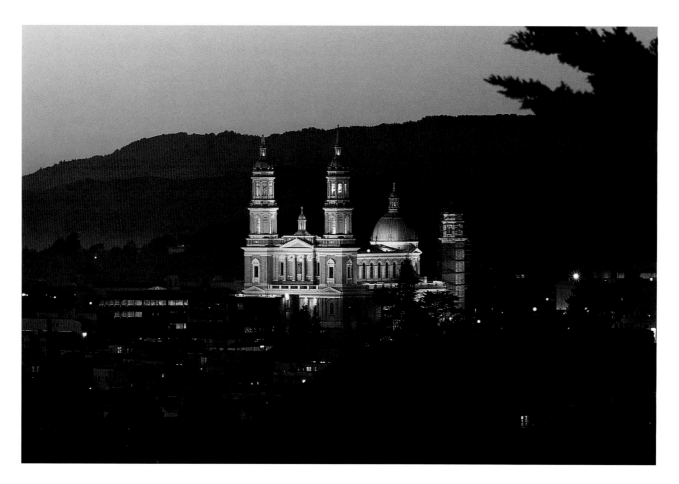

FACING PAGE: *"Gum Sahn Dai Fow"—in Cantonese, the Big City of the Golden Mountains—has been just that for a good few generations of people coming both from the east and the East.* ABOVE: *A view from Buena Vista Park to the north at crepescule includes the apparitional image of St. Ignatius Church—part of the University of San Francisco campus—and the uninhabited hills of Marin.*

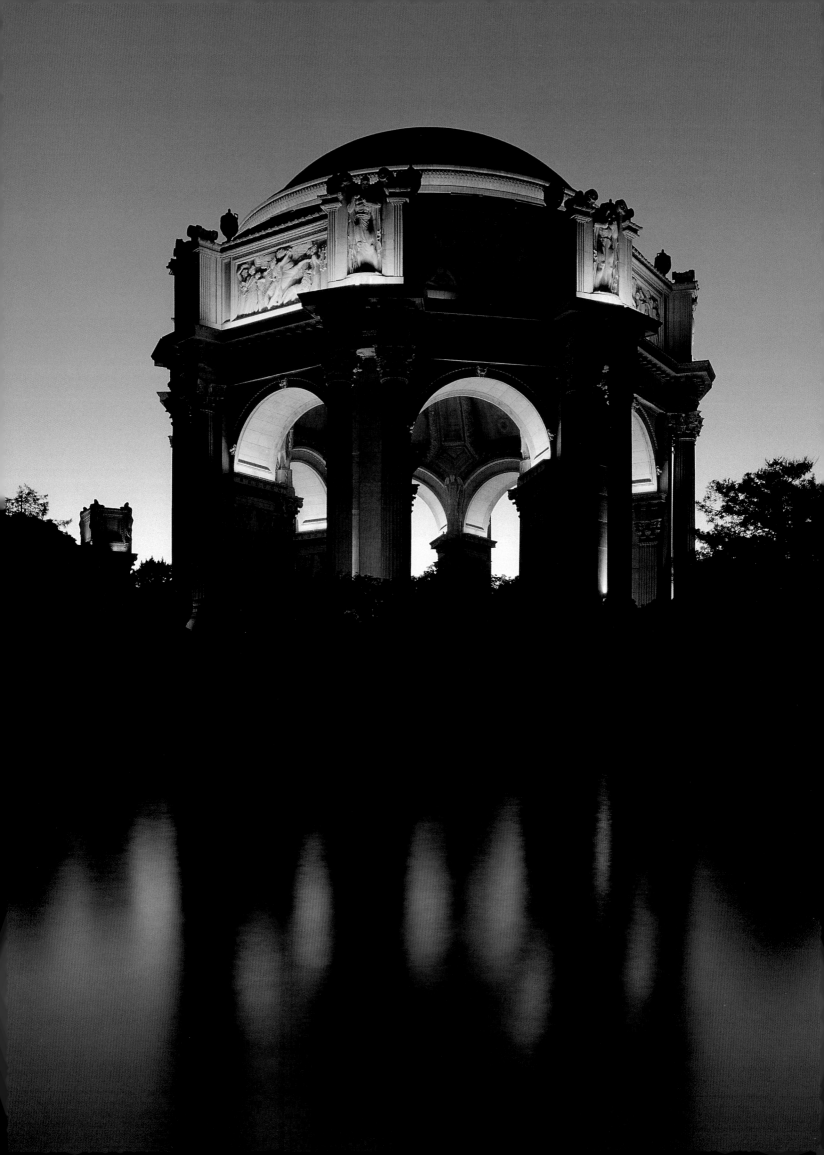

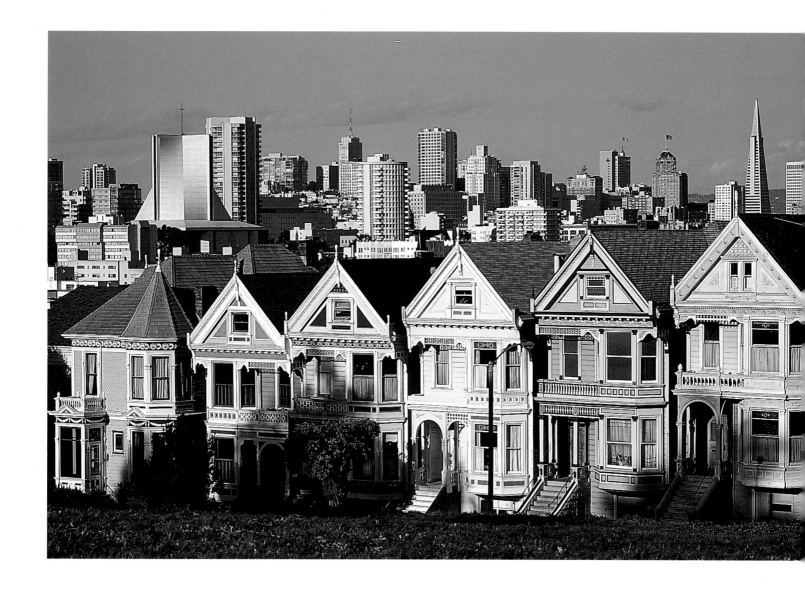

something even a bit sentimental about our desire to show that we have matched a former glory—at least, in appearance. In Paris, the new public toilets look like space shuttles. In San Francisco, they look like turn-of-the-century French facilities. But many of the things we are precious about may, indeed, be worth a bit of precious care. When, in 1982, the city halted its cable car service for two years of repairs, my wife and I had a hard time falling to sleep for the first few days. The rattling whir of the cable, the

sound of scared and giddy tourists as they pitched over the edge of Hyde and Jones had become lulling sounds as we would close our eyes, the sounds of the heart of the city ticking. Sure, the cable car is slow and

FACING PAGE: *Built as an impermanent display at the 1915 Panama Pacific Exposition to display "the mortality of grandeur," Bernard Maybeck's Palace of Fine Arts is the only structure still "grandly" standing from the exposition.* ABOVE: *We have not always loved our Victorians. Charles Keeler, in his 1902 book,* San Francisco and Thereabout, *described them as "painted board houses out of which rows of bay windows bulge vacantly, ornamented with diverse whimsicalities that are as meaningless as they are wearisome." Hmmm…*

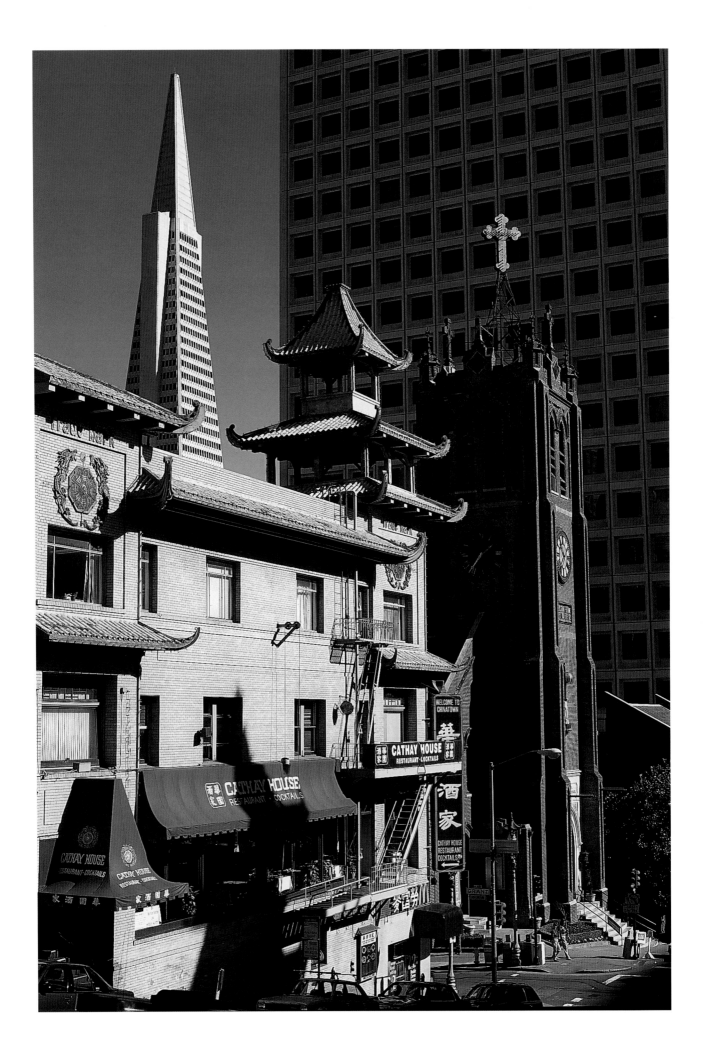

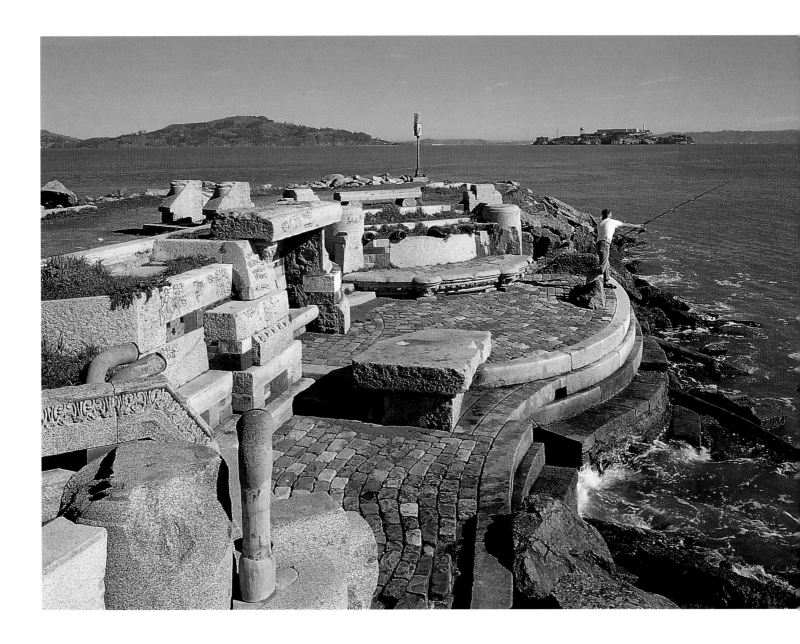

crowded and no way to get anywhere in a hurry or on a weekend. But for our children and our lovers and those who just want a moving view, there is ample reason to hold onto the last functioning cable car system in America.

Not that we haven't done the new thing in the new century with fairly regular extravagance. In the 1920s, we built some of the country's most notable Art Deco buildings. Even the Depression did not halt our growth. Both the Bay Bridge and the Golden Gate Bridge were completed in the mid-1930s.

This is not to say that San Francisco was spared the bleak effects of the Depression. In 1934, for a pool of four thousand available longshoremen only thirteen hundred jobs were available, many of them held by scabs desperate for whatever they could get.

FACING PAGE: *The quick construction of the Sing Chong building with its distinctly oriental details deflected the effort to remove the Chinese influences from Chinatown after the 1906 earthquake.*
ABOVE: *This "modern ruin" hides a tangle of pipes that, when the tide is right, gurgle, groan, wheeze, and whisper with the sounds of the sea. Hence its name, the Wave Organ.* FOLLOWING PAGES: *Poetry's pub and the public's poetry—the twins of the muse and amusement at either corner of Jack Kerouac Alley in North Beach.*

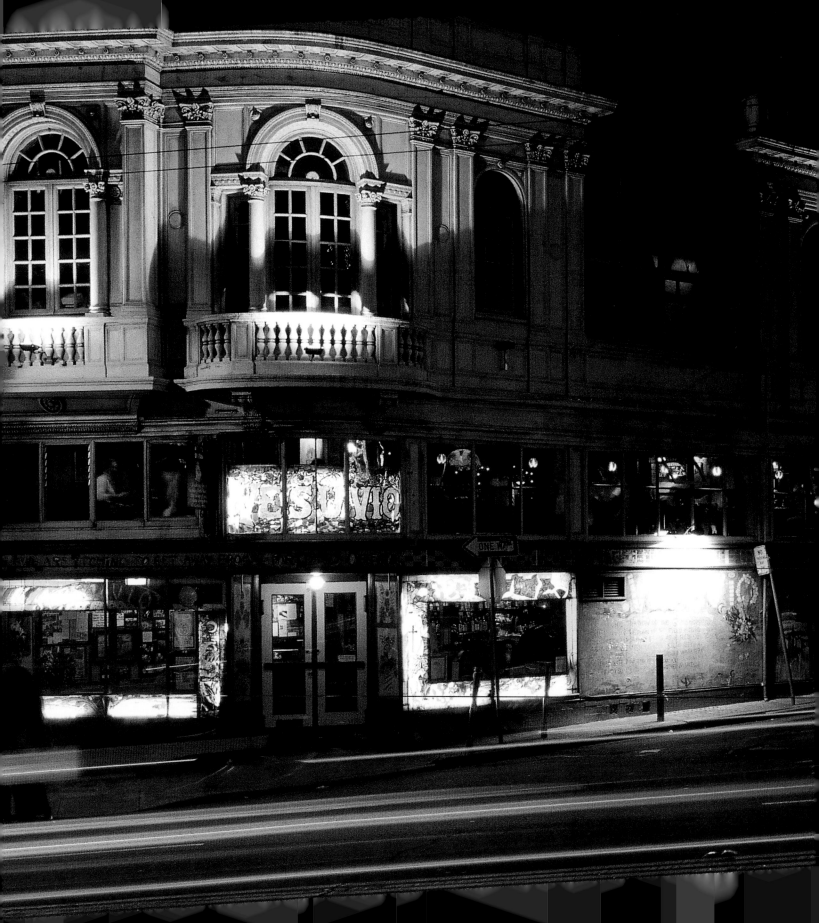

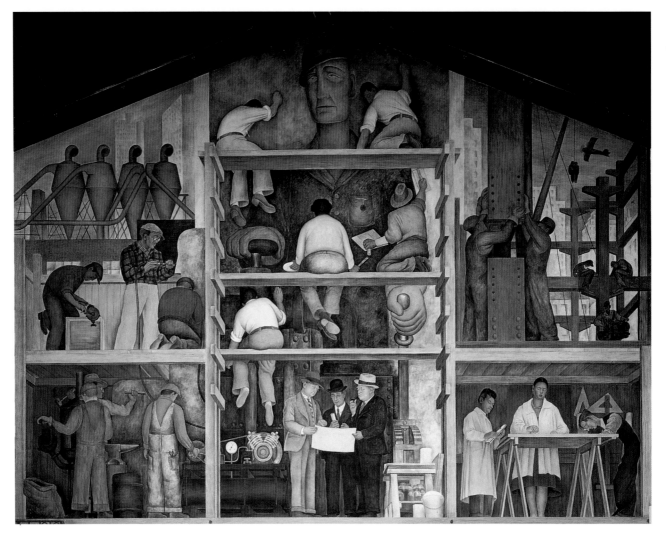

San Francisco responded with fairly typical grass-roots passion. Organized against the consolidated practices of the shipping companies, the Longshoreman's Union called a strike. On July 5, 1934, two strikers were shot and killed by the police. This led to a general strike in which much of the city was shut down. "Bloody Thursday," as it was called, saw the largest labor sympathy strike in American history. And it got results. The shipping companies subsequently hired union workers and paid them (half) decent wages.

Eight years later, it wasn't too little work but too much that affected the city. With

ABOVE: Diego Rivera's mural at the San Francisco Art Institute may be our most famous mural but it is only one of hundreds, many of them spontaneously enshrined on warehouse walls and garage doors around the city. FACING PAGE: Rodin's "Thinker" is framed for contemplation at the Beaux Arts entrance to the Museum of the Legion of Honor, a recently renovated museum housing some of the region's important nineteenth and twentieth century European paintings, not to mention an important collection of Rodin's sculpted works.

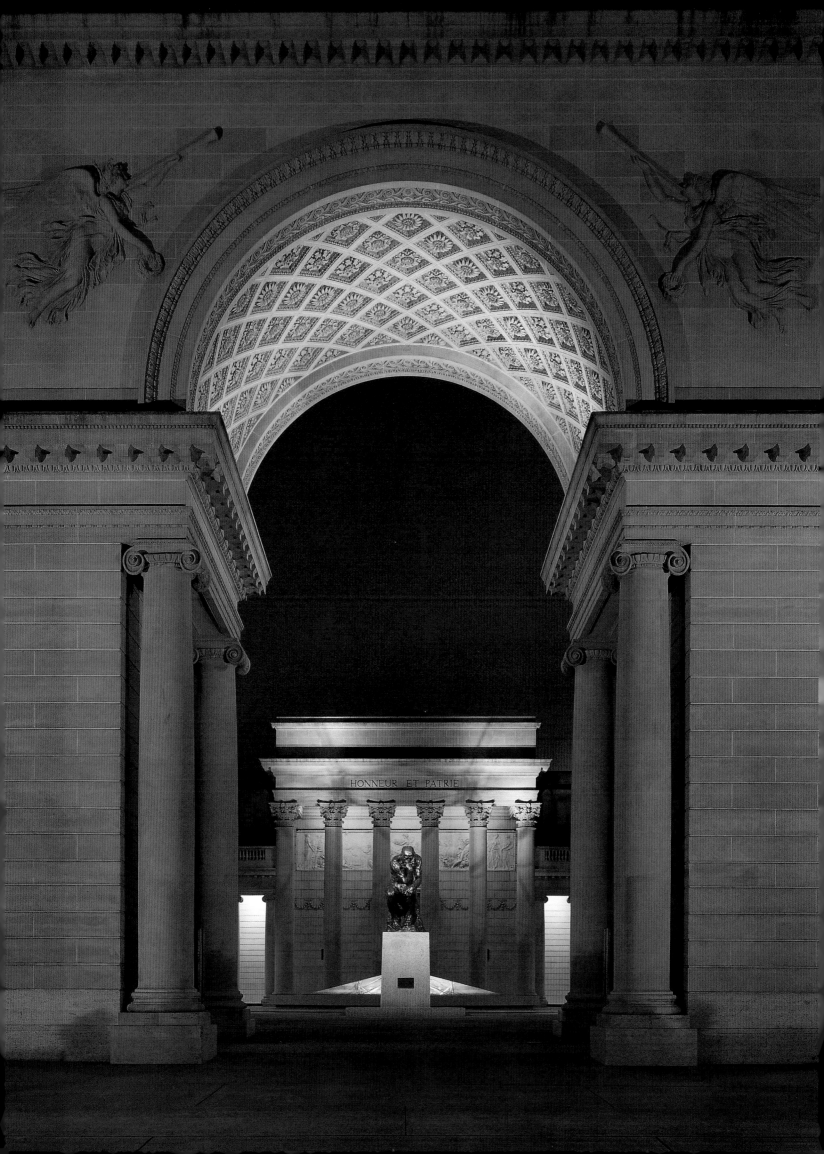

HONNEUR ET PATRIE

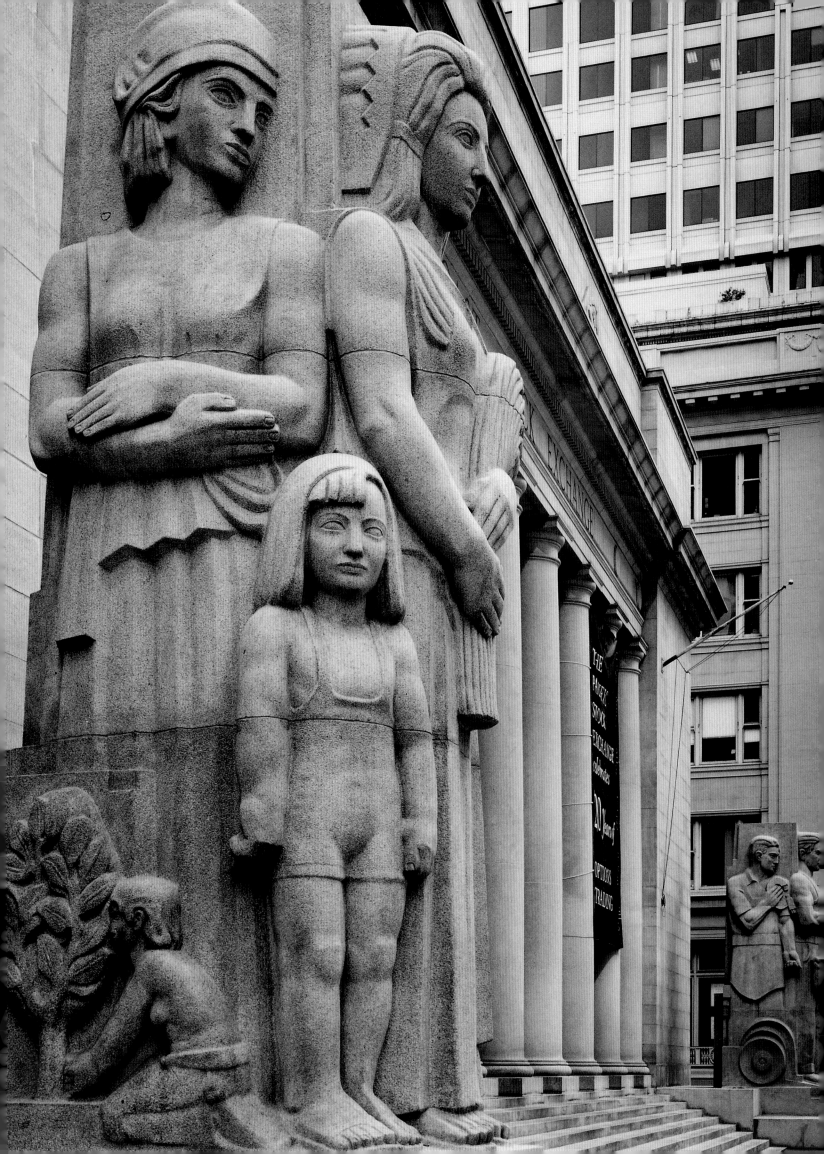

Pearl Harbor destroyed, San Francisco became the main port for the war in the Pacific. Henry Kaiser and the thousands who worked with him built Liberty ships faster than anywhere in the States. And San Francisco needed them. This was the port from which hundreds of thousands of men and women would leave for the war, and the port to which hundreds of thousands of men and women would come "on leave."

After the war was over, however, many decided never to leave again. The population quickly approached what it is today. With city and county congruent and almost all of our open areas protected, it's hard to build anything new without taking down something that's old.

Which is not to say that we have not done some impressive building since the war. The downtown skyline is almost unrecognizable compared to what it was twenty-five years ago. (Long live the Ferry Building—that waterfront referent to ages and ways gone by.)

Most changes since the war have occurred in our streets or behind closed doors. The smoke-filled dives of the raving '50s, the head shops of the smoking '60s, the bathhouses of the swinging '70s, the

FACING PAGE: *Flanking one side of the Pacific Stock Exchange is a somewhat incongruous group of Native Americans seemingly more bent on the growth of vegetables than of various mutual funds.* BELOW: *A wonderful and quick romp through the past can be had at the Wells Fargo Bank History Room on Montgomery Street downtown—rich with details of the wild and rapid movement to the West.*

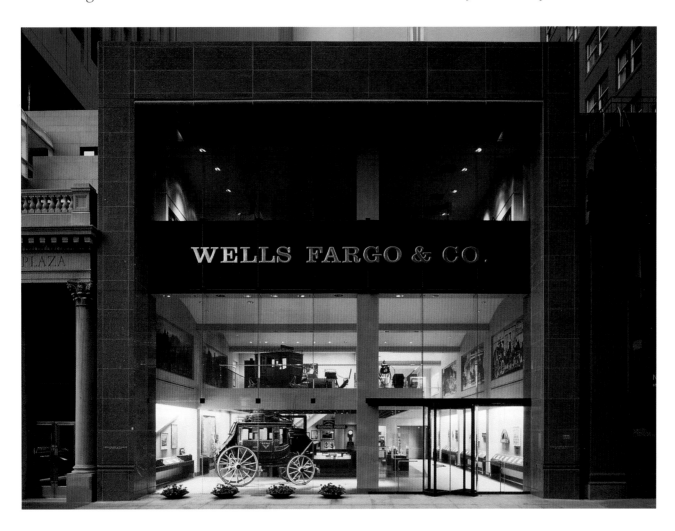

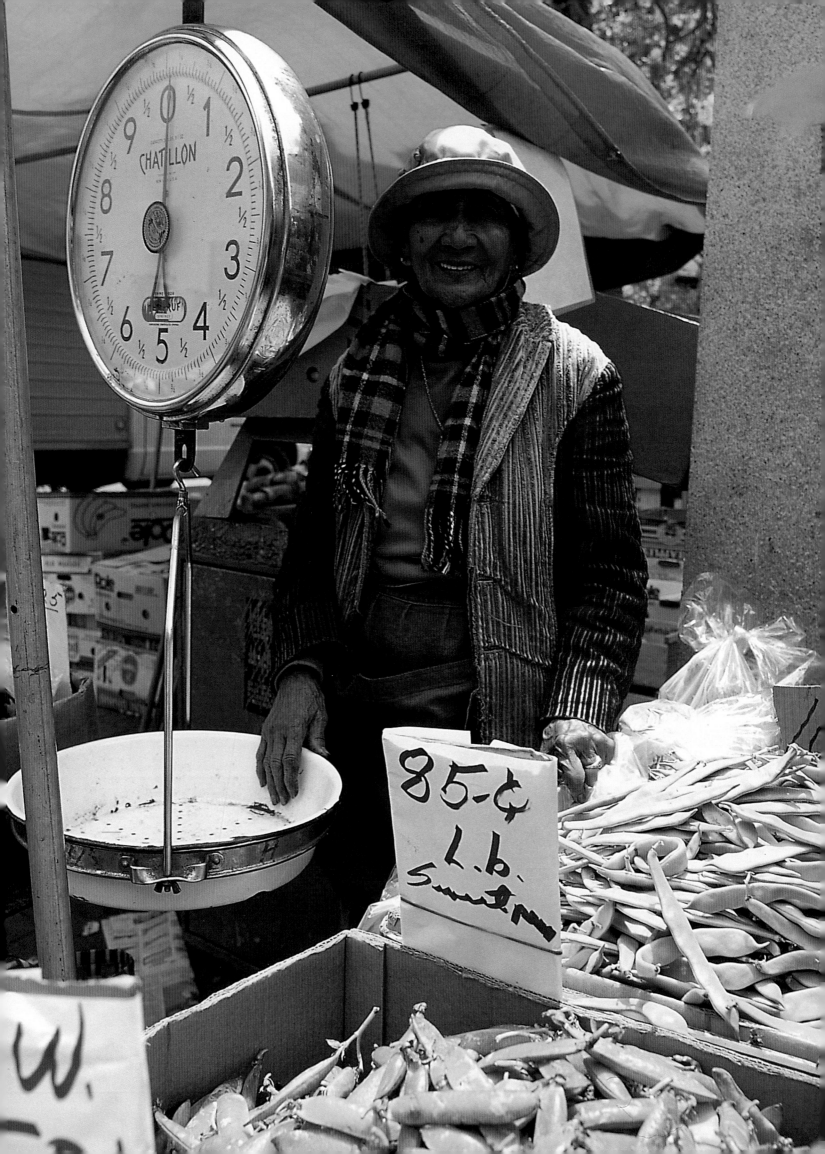

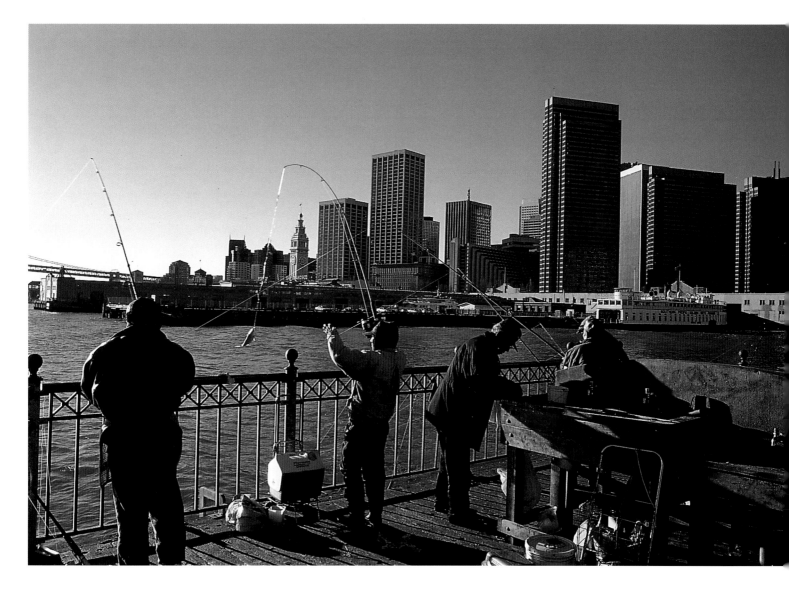

restaurants of the wining and dining '80s, the dance or jazz or retro or rave clubbing '90s—most of the best of what San Francisco has recently been has mostly been reflected in the styles of life and less in the styles of the things we build.

We have, in fact, been called the "lifestyle capital of the world"—not always in the most positive tones. So be it. That San Francisco has always had an abundance of both life and style is good enough reason for most of us to add a little of both to the present.

FACING PAGE: *Growing in popularity are the street markets of San Francisco. Here, at the United Nations Plaza in Civic Center, all manner of fruits and vegetables are sold of a Saturday morn.*
ABOVE: *We may rely on various markets for our vegetables and fruits, but the bay still offers a harvest of fresh, if usually small, fish.*

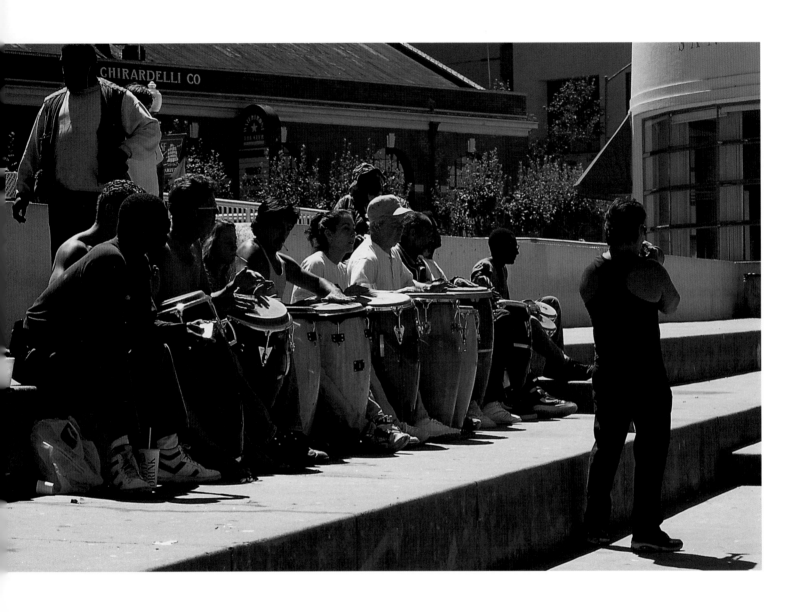

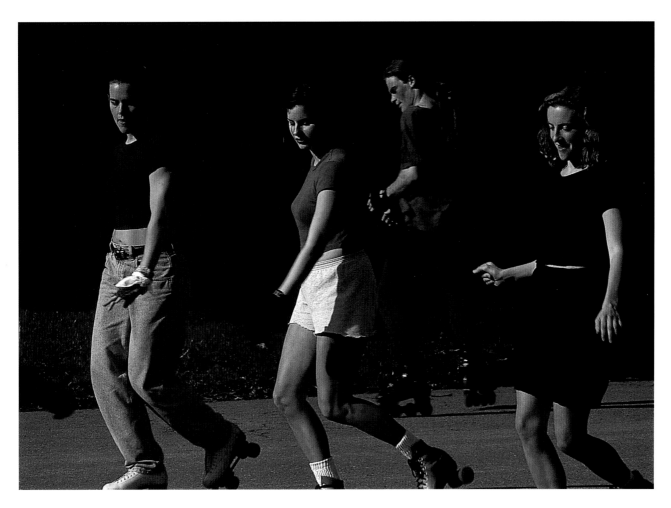

FACING PAGE: *For years, the steps above Aquatic Park have hosted a weekend rhythm jam. On good days, the rhythms can be tight and wonderfully complex.* ABOVE: *Dancers practice a wheeled routine,* *with background music, for whoever happens by in Golden Gate Park.* FOLLOWING PAGES: *Silver with fog, golden with early morning sun— one of the quiet joys of waking and walking early in the city.*

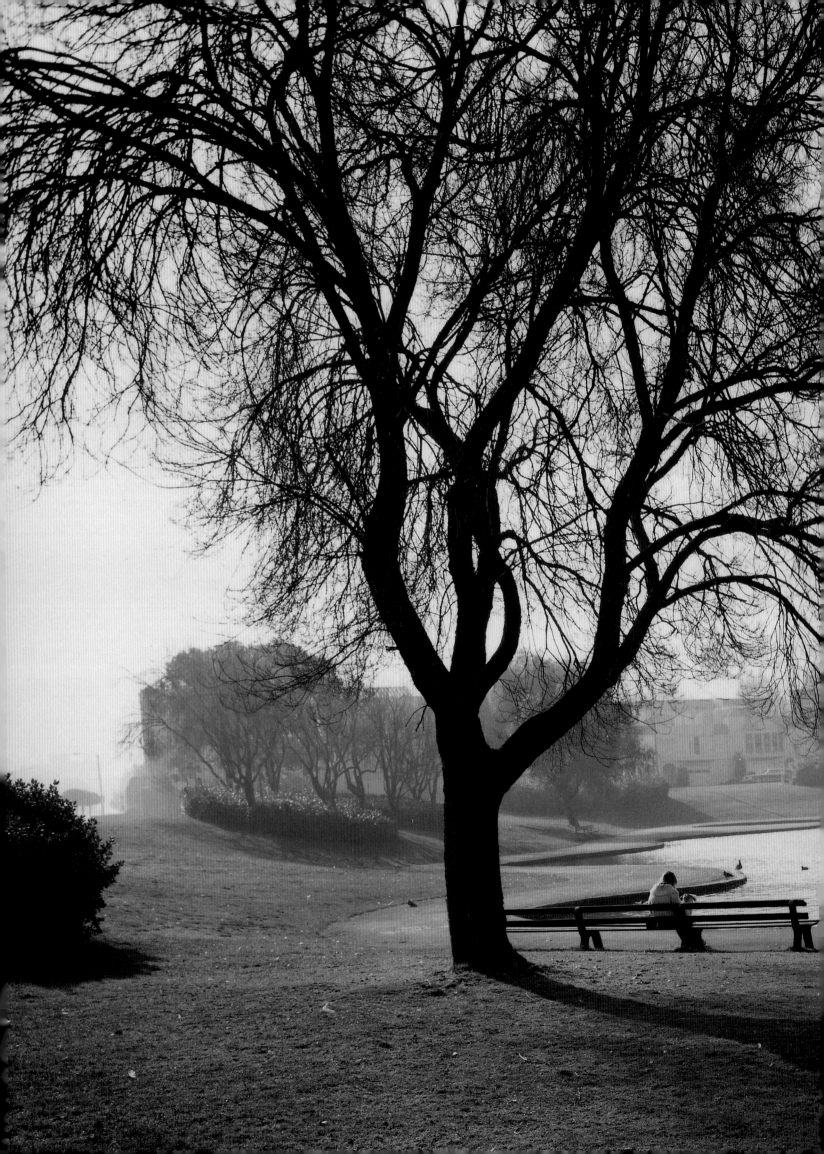

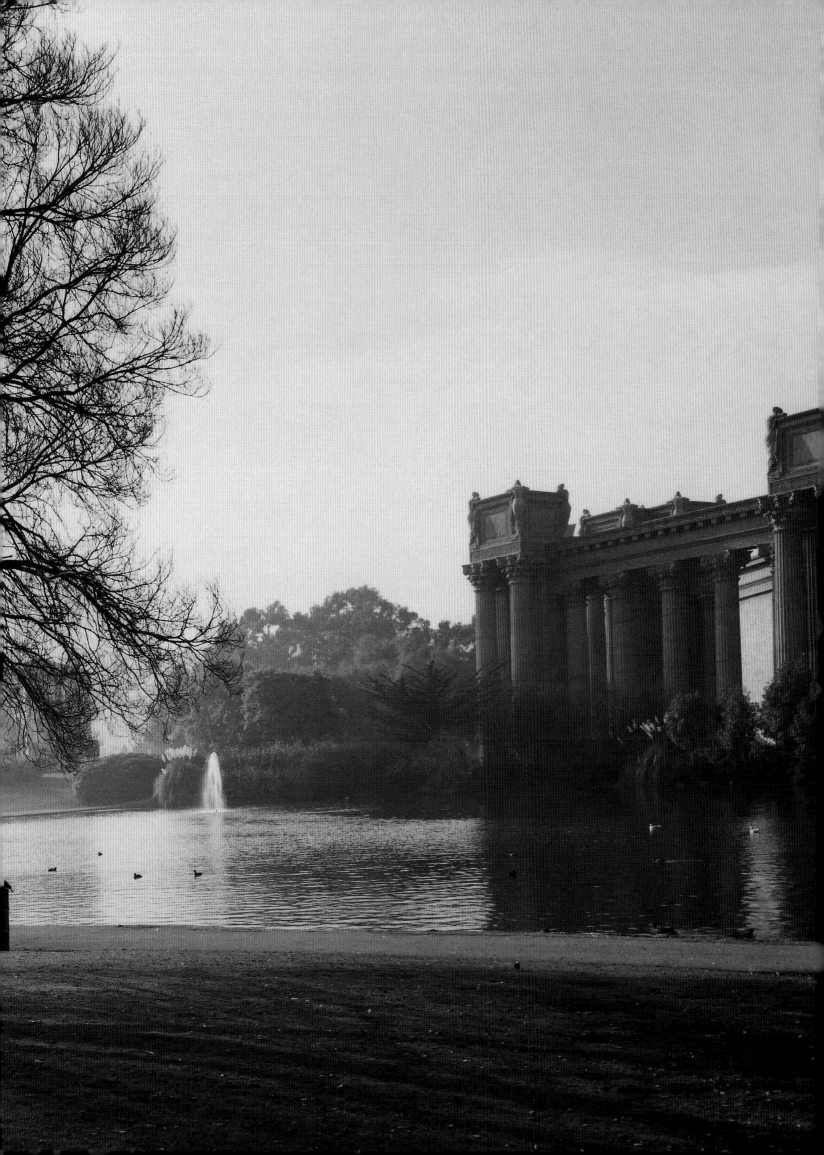

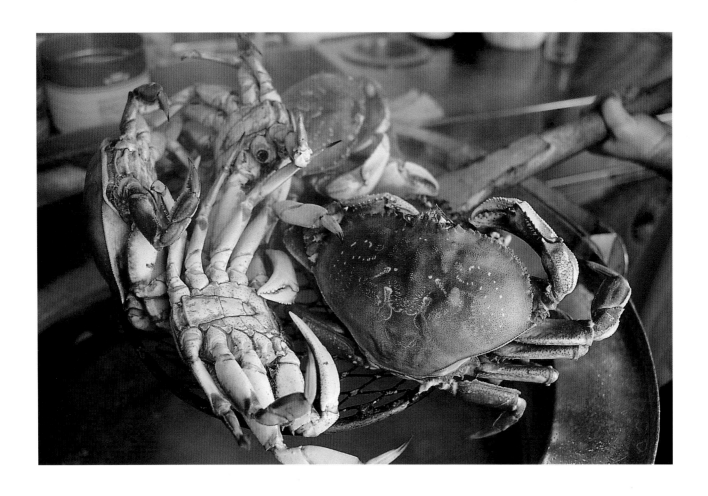

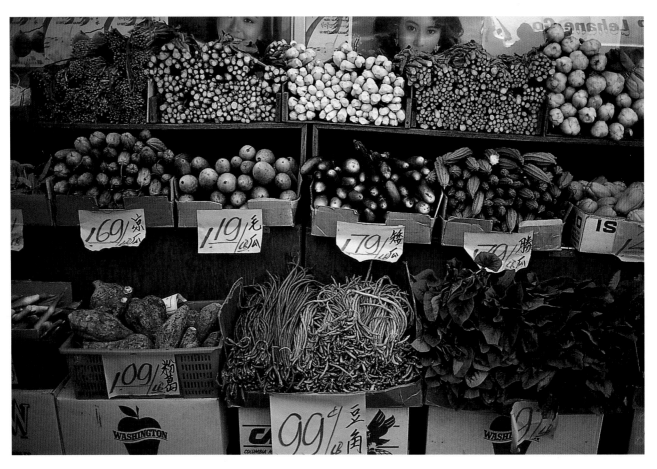

Above and Facing Page: *Living, as we do, in "Californicopia," we are increasingly addicted to food that is both fresh and varied,* such as the locally harvested Dungeness crab and as many kinds of fruits and vegetables as you can shake a name at.

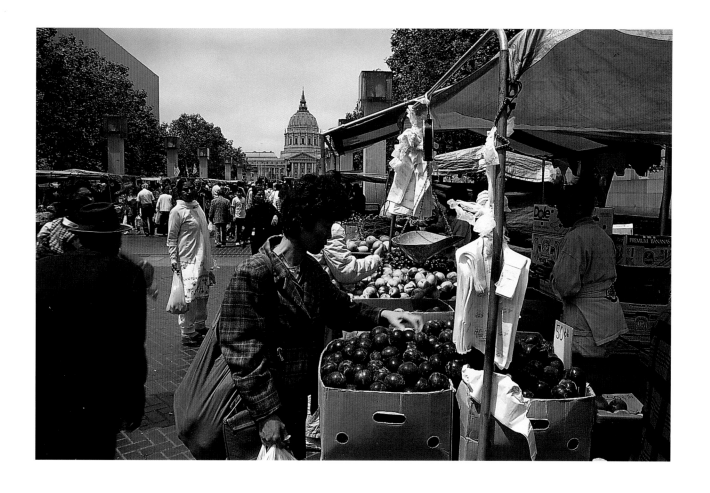

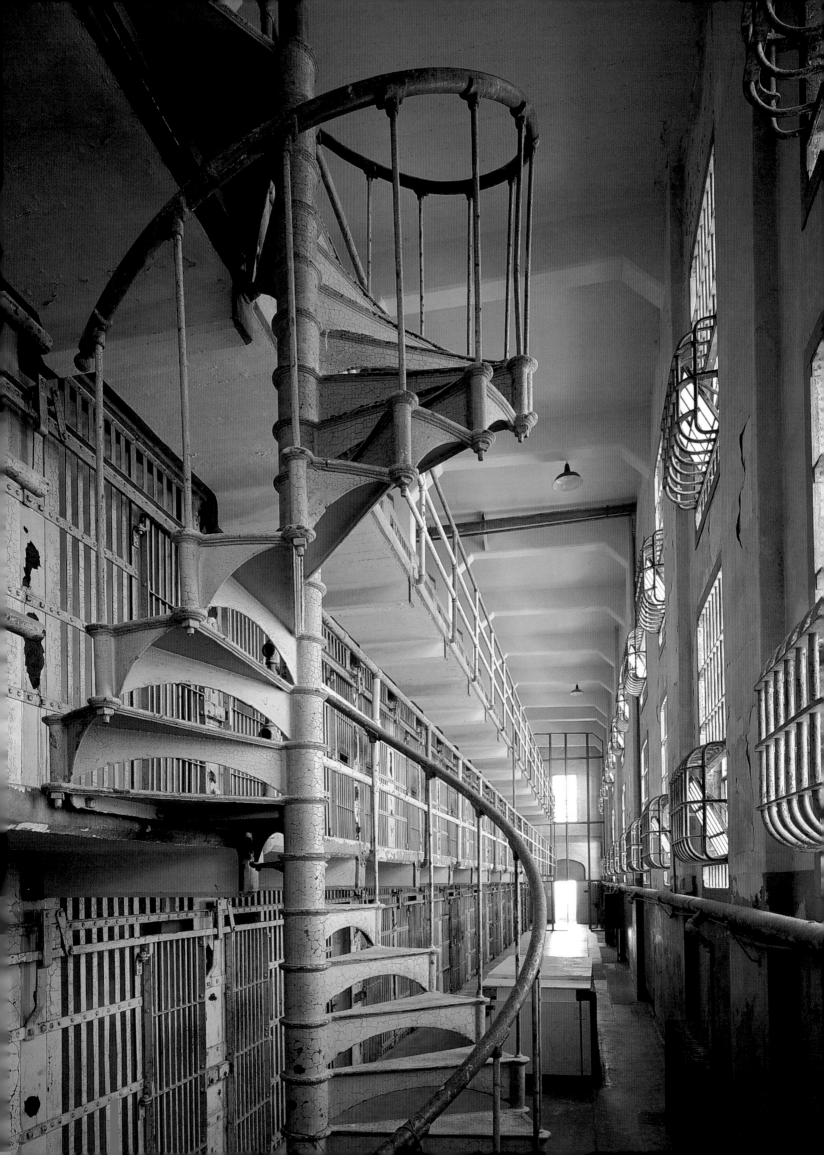

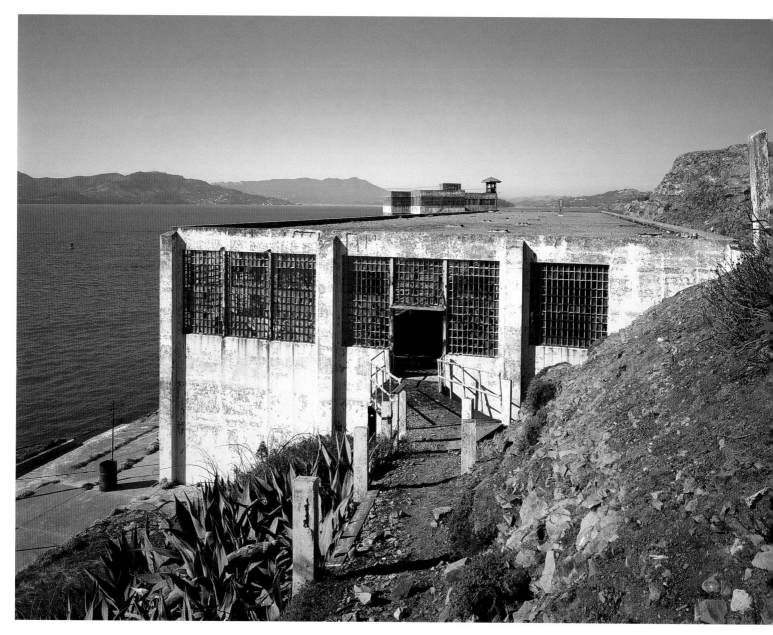

FACING PAGE: *"The Rock," otherwise known as Alcatraz, is just that: a big rock in the middle of the bay, always visible but hard to reach and—for the decades of prisoners incarcerated on it— impossible to escape.* ABOVE: *Before it became yet another part of the huge Golden Gate National Recreation Area in 1973, Alcatraz Island was occupied by Native Americans from 1969 to 1971.*

Because Native Americans once considered most of the Bay Area to be their undisputed home, their claims were not entirely specious. FOLLOWING PAGES: *Below the Ghirardelli sign is the nautical-looking Maritime Museum. Above the sign are the swanky slopes of Russian Hill. And right at the sign is one of our many tourist meccas— the many storied shop-spot of Ghirardelli Square.*

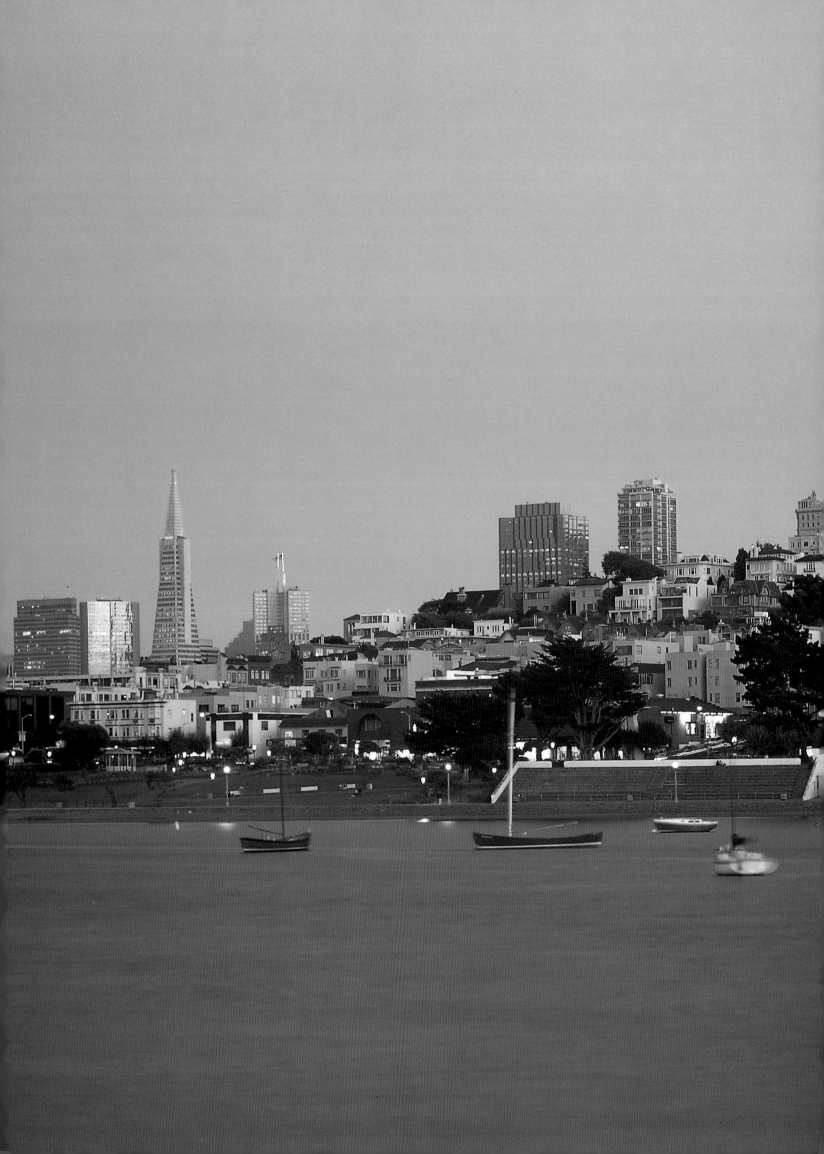

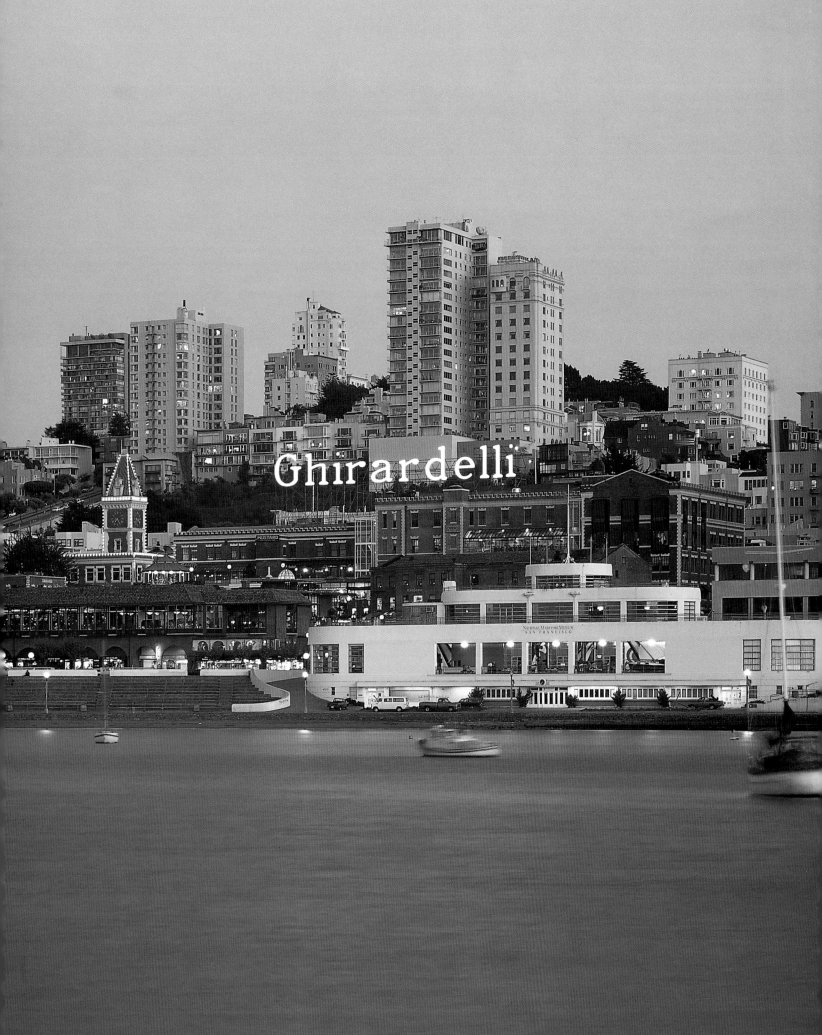

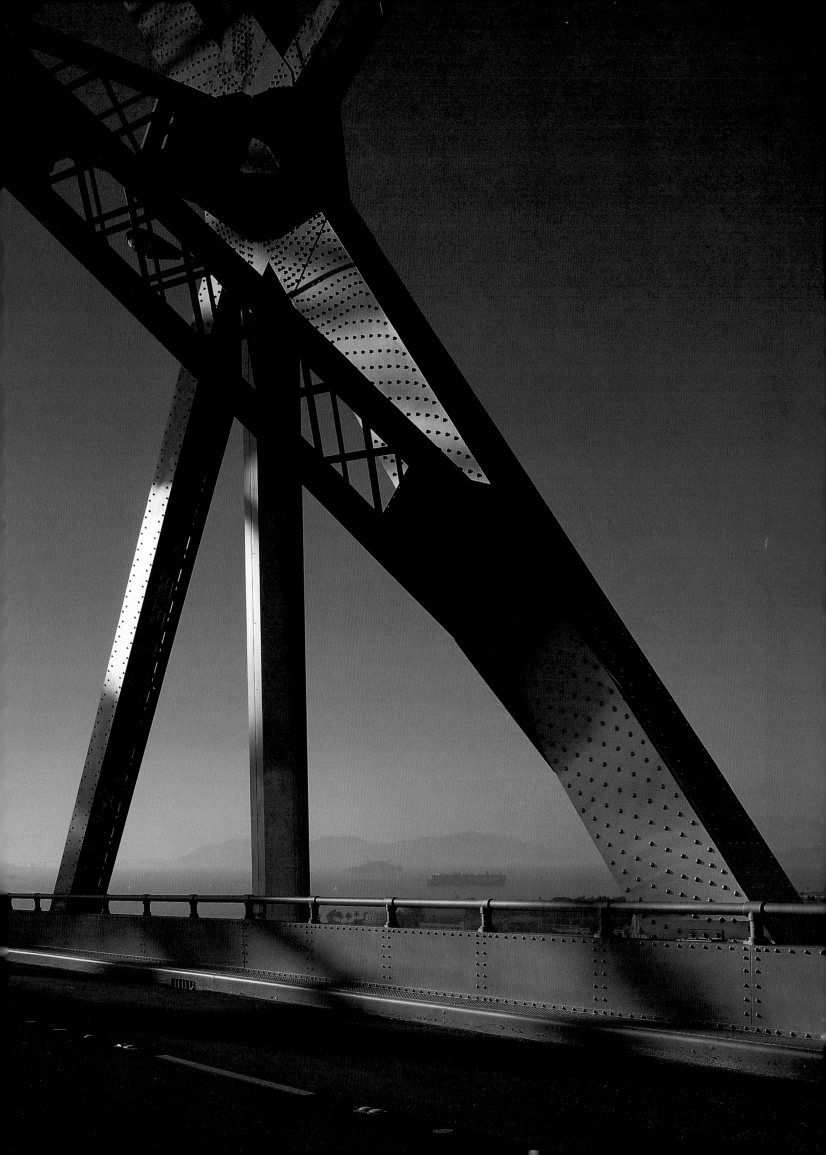

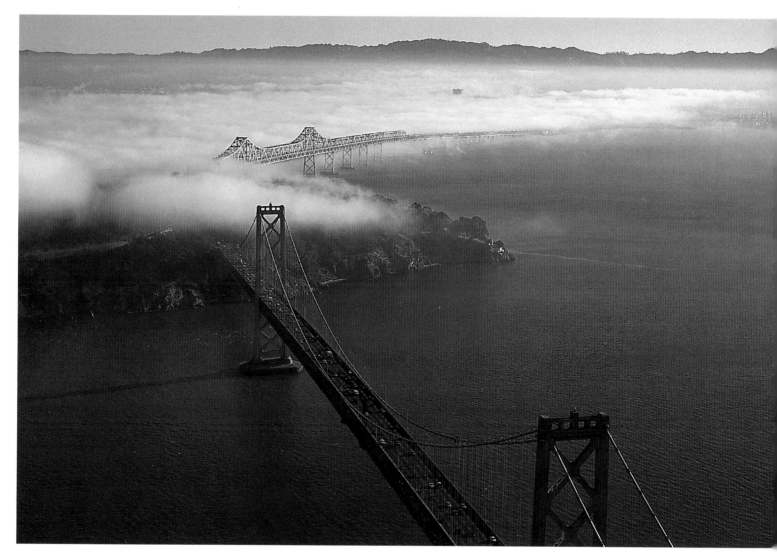

FACING PAGE: *The road more traveled, though less well rhapsodized, is the Bay Bridge. Though less stately than the Golden Gate Bridge, views from the upper (westbound) deck are every bit as beautiful.*

ABOVE: *In actuality, the Bay Bridge is two bridges, rather than one. Connected at Yerba Buena Island in the middle of the bay, its two parts are even built differently.*

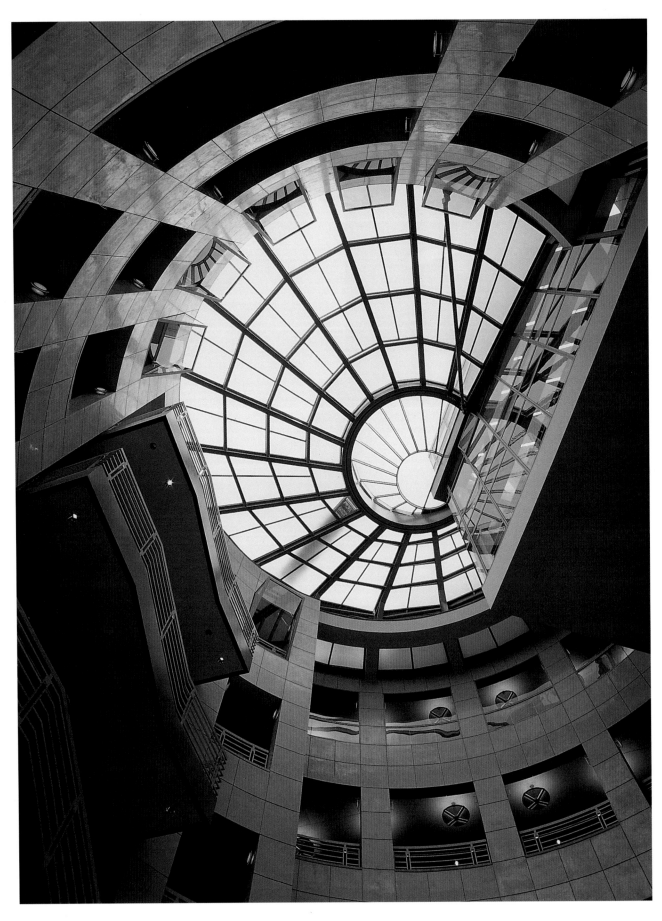

ABOVE: *A new look for the cathedral of books: Cantilevered balconies and a stunning post-modern swirl help to house the new main library of San Francisco.* FACING PAGE: *Ironically, perhaps some of the best art and architecture anywhere in America was created during the Depression. The controversial murals of Coit Tower were commissioned in 1934 by the Public Works of Art Project.*

At the Core of the Culturevolution

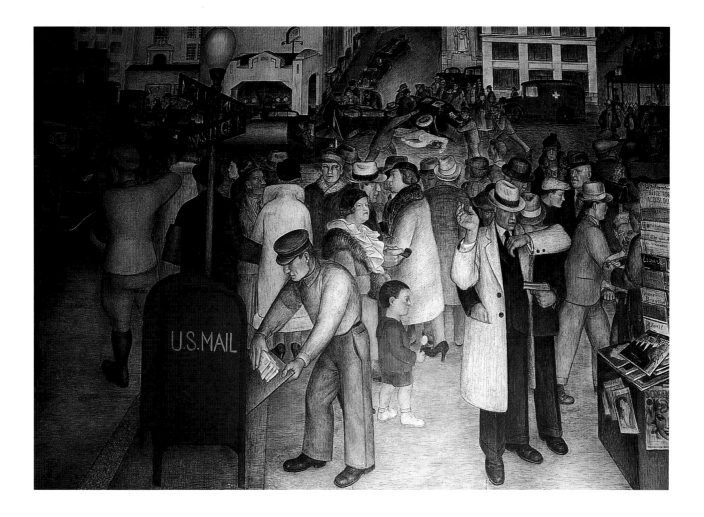

*Here is an end
and a forced beginning;
the land defined but the purpose—
still to be explored.*

It is tempting to claim that San Francisco exercises the first right of refusal for America's cultural revolutions. When elsewhere has been nowhere for such things, people have come here to learn the racy steps of the "turkey trot" and the "grizzly bear," listen to Jimmy, Janis, or the Airplane live and loud and free in the park, raise Victorian skirts and lower Victorian standards, drink shamelessly and gamble, drop acid and dance, rave their poetry, shave their heads or wear a dress (or both).

It is, as one pleased pioneer remarked, "The best place to come for the worst virtues in the world." And in more ways than one, we have been accused of going off the deep end. The symptoms seem to have appeared early. A prominent physician in the 1850s remarked that in San Francisco, "Insanity, as might be expected, is fearfully prevalent."

And how do we plead?

Guilty, but neither of madness nor a shameless immorality but quite simply of a fundamental tolerance. People have come

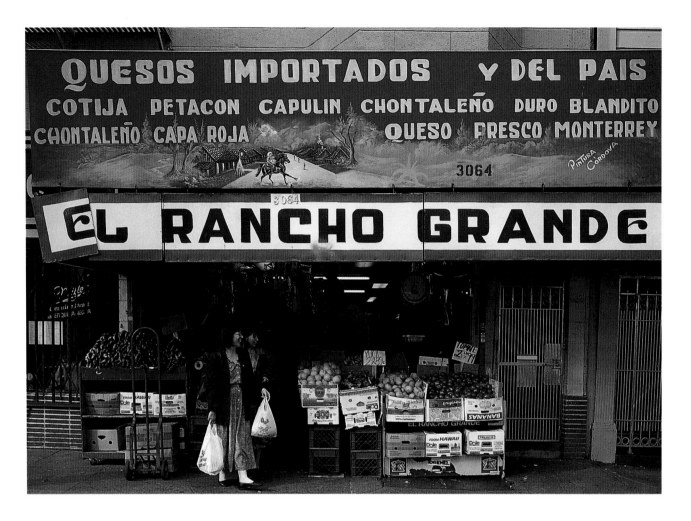

here from around the globe to live and let live, to make their small—or large— fortunes, to dance, cook, laugh, or love the way they want to. As the irrepressible Herb Caen once "liaisonically" remarked, "To each his own, to each his zone."

Even the Mormons came here to do their thing hoping, on this distant shore, to escape the secular meddlings of Uncle Sam. Alas for some of their plans, they arrived too late. Upon seeing the Stars and Stripes above Portsmouth Square, their firebrand leader, Sam Brannan, is said to have said, "There's that rag again." He didn't complain long, however. Quickly abandoning his religious calling for other opportunities on the edge, he set up San Francisco's first newspaper, *The California Star,* from which, self-servingly, he proclaimed the discoveries of gold. The ensuing rush made Sam Brannan a very rich, if somewhat dissipated, man.

Truly, San Francisco is a place where opportunity is protean.

But why here and now and even before? Richard Rodriguez has remarked that San Francisco is a city "geographically in extremis, a metaphor for the farthest flung possibility, a metaphor for the end of the line...." And it is never so clearly so as in the fall when the wind blows warm and brittle from the east. Then, from some high perch, the view to westward is both exhilarating and unnerving. The demarcations are so brutally sharp. The land ends and then there is ocean and above that, sky—both blues receding to

ABOVE: *"El Rancho Grande" (The Large Ranch) in name, at least, recalls a time when the grand ranches of the Mexican "Dons" claimed most of the land in and around San Francisco. In fact, in the same year, 1776, when England was served its walking papers from the East Coast, the West Coast—including San Francisco—was claimed for the king and queen of Spain.* FACING PAGE: *Vibrant colors, banners, streamers, firecrackers, dragons, and drums are just a few of the elements of many a celebration in Chinatown.*

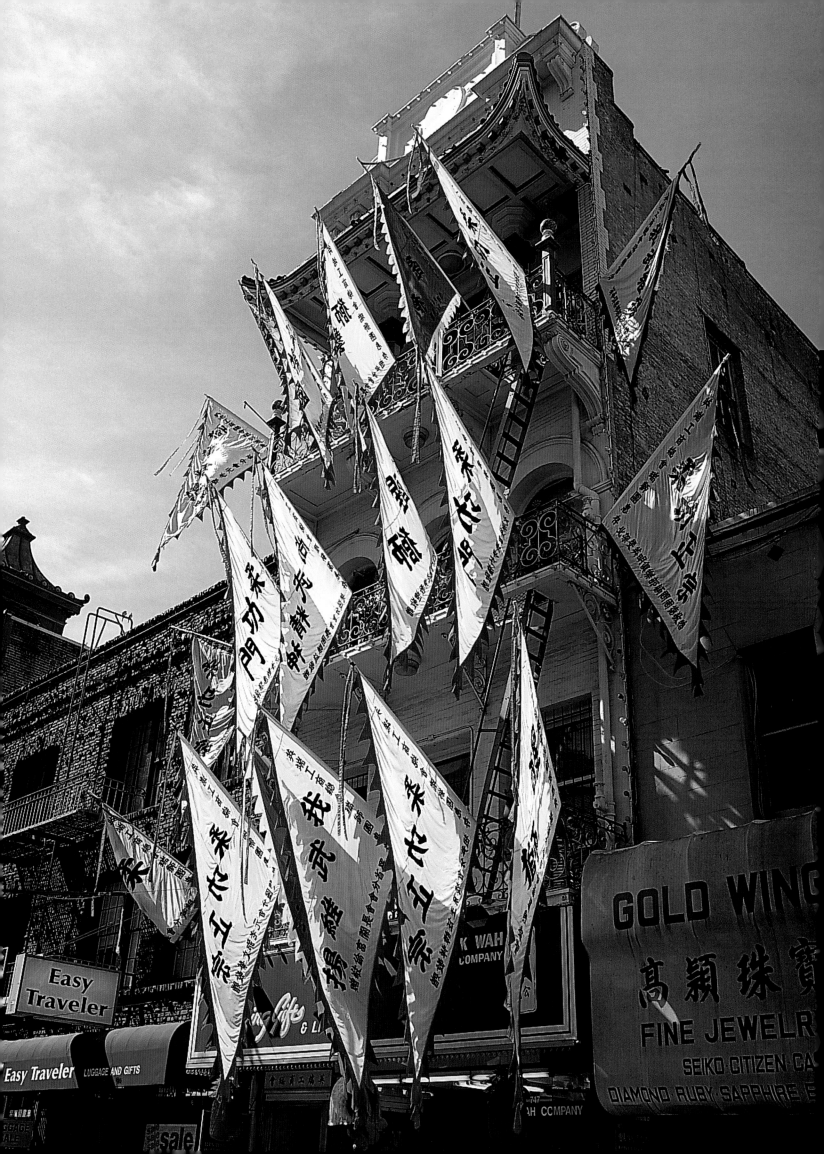

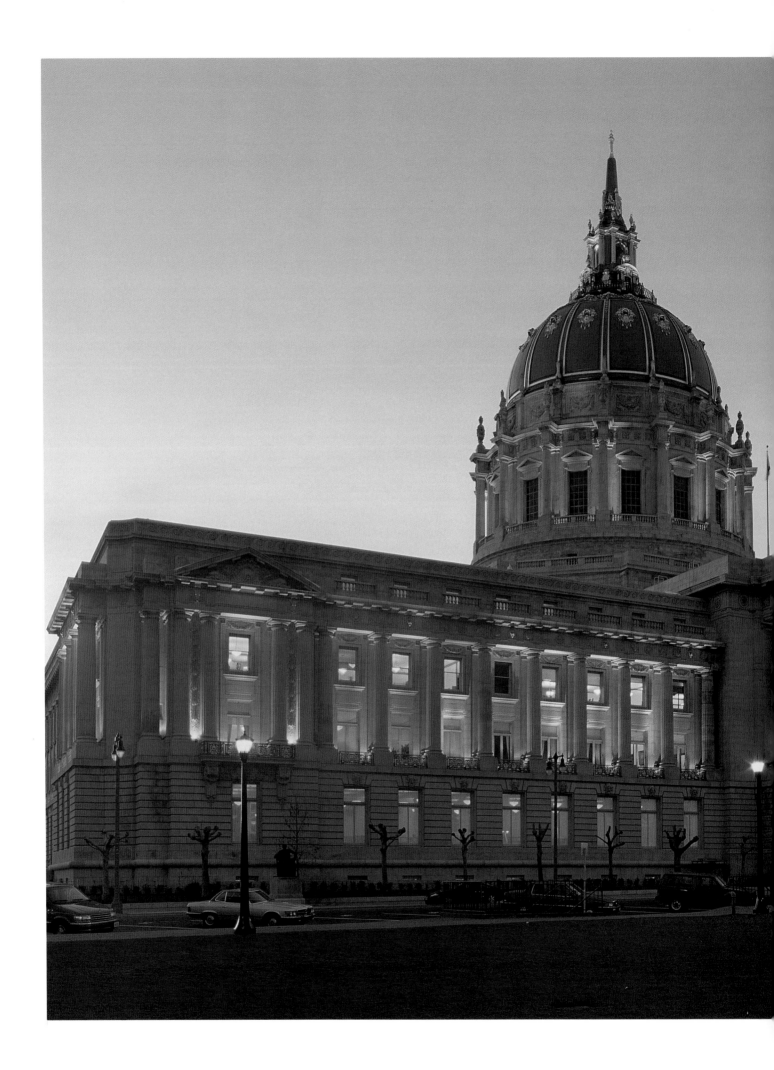

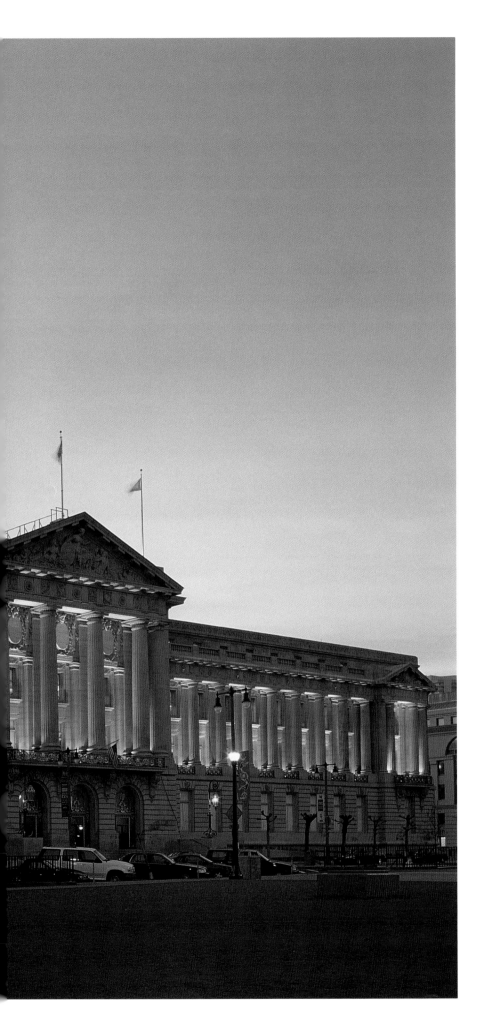

LEFT: *As if a retrofitted phoenix, the new/old city hall spreads its gilded wings in the revitalized nest of the city's Civic Center.*

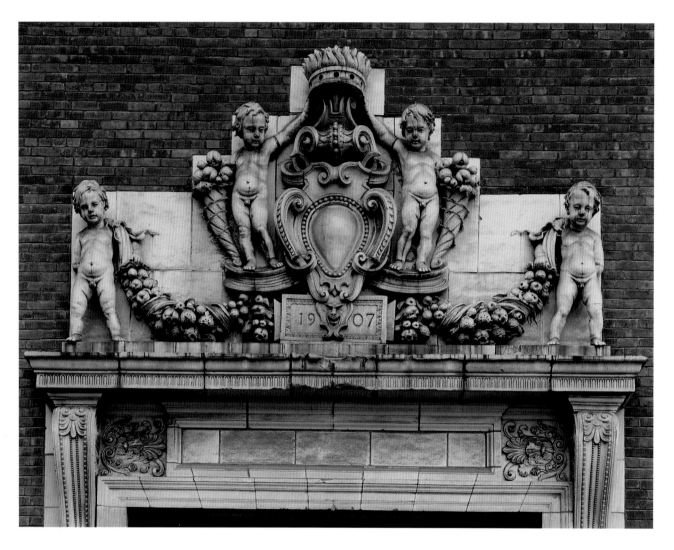

places only touched by imagination. There is much that is unfamiliar, unhusbanded, and gloriously untouchable about our surrounding geography, and this fact has contributed in no small measure to our cultural geography.

San Francisco is not, however, just the end of the geographical line for America—some vibrant and anxious full-stop to our migrations. As Mr. Rodriguez suggests, "to speak of San Francisco as land's end is to read the map from one direction only." We have trudged, galloped, flown, or floated up to this place from every possible direction—in large numbers. For some, this has been a terminus. For others, a point of departure.

And for all, a place like no other on the face of the globe.

So who are these (for the most part) lucky people?

I suppose the only thing that can be said both in truth and in general is that these are people who are not overly troubled by fog in the summer or heat in the winter, by 6.8 earthquakes or Chinese names, by African rhythms, English tea, or Mexican holidays.

ABOVE: *This "burst of putti" embellishes the entablature on an unlikely brick box; the Pacific Gas and Electric substation. Ah, but that was in 1907, a year after the earthquake, and even the humblest of structures often bragged of a brash renewal.* FACING PAGE: *The hanging gardens of the Hyatt rise above a spacious, dramatic atrium.*

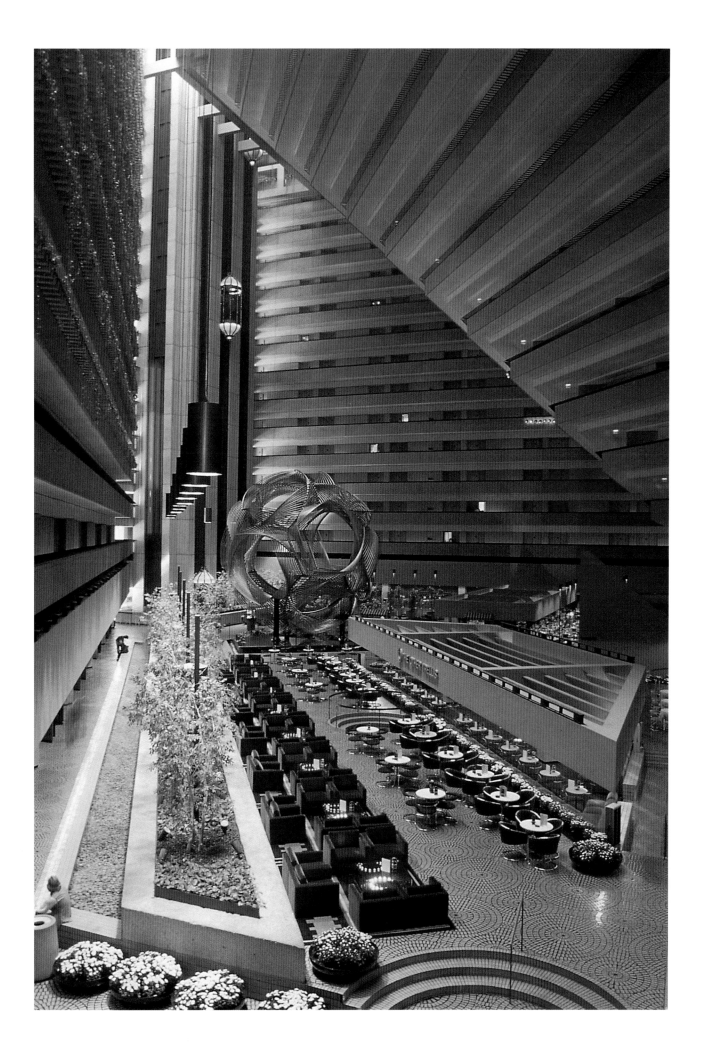

To sketch but a few....

—there is the young woman in dayglo spandex whose short hair is greased and spiked; she stands behind us—out of breath—at the counter waiting to order her third "grande" (big) "cap" (cappuccino) "wet" (with lots of milk). She will take it to go and put it, to go, on the handlebars of her ultralight, politically stickered mountain bike, and then ride off to her yoga class....

—there's the "brother"—says he used to play with Basie and there's no good reason to doubt him—who brings his horn to the "Saint John's African Orthodox Church of the West Apostolic succession by favor of Ignatius Peter III Patriarch of Antioch," otherwise known as the Church of John Coltrane, there to swell a reverential riff with his high, clean, God-soaring tones....

—there are the dancers of the Escola Nova de Samba—white, black, Asian, and Hispanic—who shake a few feathers and a lot of flesh during the (usually windy) Carnival in spring—the largest to take place anywhere outside of Brazil....

—there's the wife of the man who came here from China just before the war and started a small green grocery store that became a big green grocery store that made it possible for one of their sons to start a very fine restaurant in which she, the mother, likes to sit and finger a discrete necklace of pearls and smile, proudly, distractedly, as a conversation swirls around her about the tannins in a new merlot....

—then there are the next-door neighbors, a couple of fellows who have been together for ten years and have, for almost as long, polished their vintage Dodge

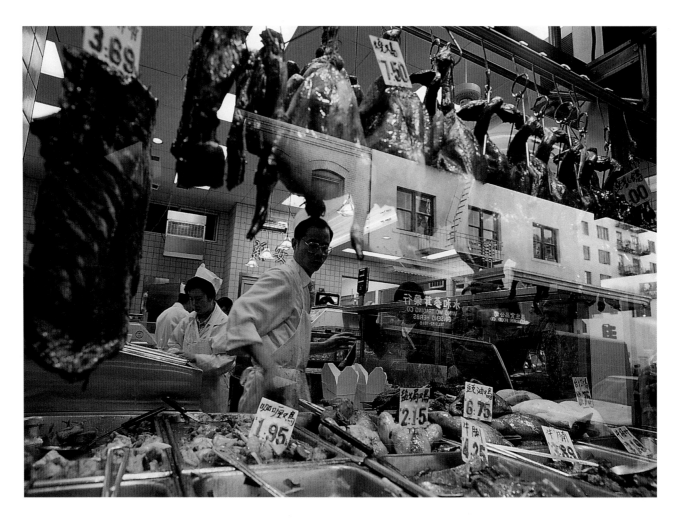

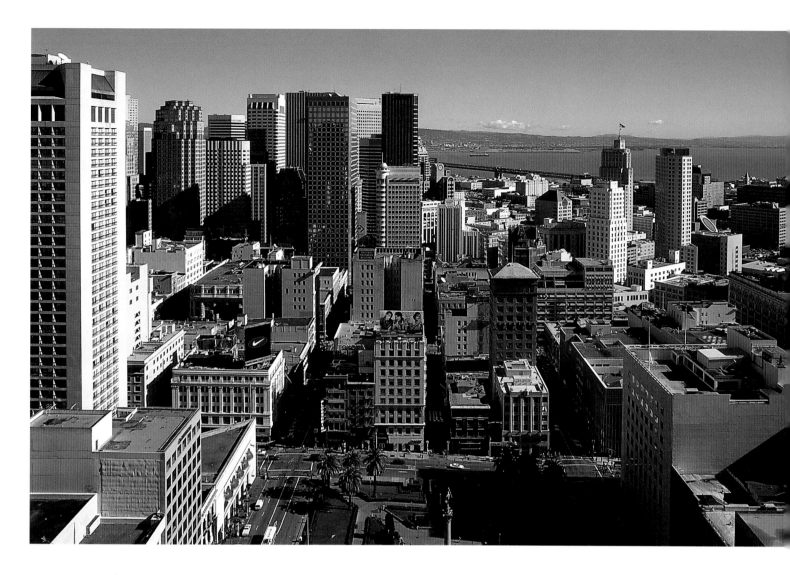

every Saturday morning and gone bowling every Saturday night.…

—or there is the pair; he, an MBA from Stanford with papered roots to the *Mayflower,* she, a Ph.D. from Cal, traceable to Mexican-become-Californian fruit pickers in the late 1930s and the Toltec in the early fourteenth century, who now, together, live in a small studio apartment midway to the top of Nob Hill.

We are all of these and a whole lot more—723,959 to be possibly precise. The census takers tell us we are relatively young, relatively well educated, very crowded, and extremely diverse. Our housing prices are the highest anywhere in the continental United States; 34 percent of our population is foreign born; and the whole lot of us live on about the smallest piece of urban property in civilized America. We are, as well, a singles city—a fact that has undoubtedly contributed to our ability to "tune in, turn on, and drop out."

Nonetheless, averages are often little more than the arranged marriage of extremes. Robert Reich once remarked that the height of the average man, derived by comparing his height, 5'1" (a very short man) and Shaquille O'Neil, 7'3" (a very, VERY tall man) would be 6'2"—hardly comparable to either man.

FACING PAGE: *What you see is what you get at most of the Chinese markets clustered around the city. Often, the "food" is still alive in cages, as well—a fact that contributes to the general peculiarity of the entire shopping experience.* ABOVE: *From the Starlight Room atop the Saint Francis Hotel, one gets a good glimpse of Union Square, below, around which much of the city's most conspicuous (and stylish) consumption takes place.*

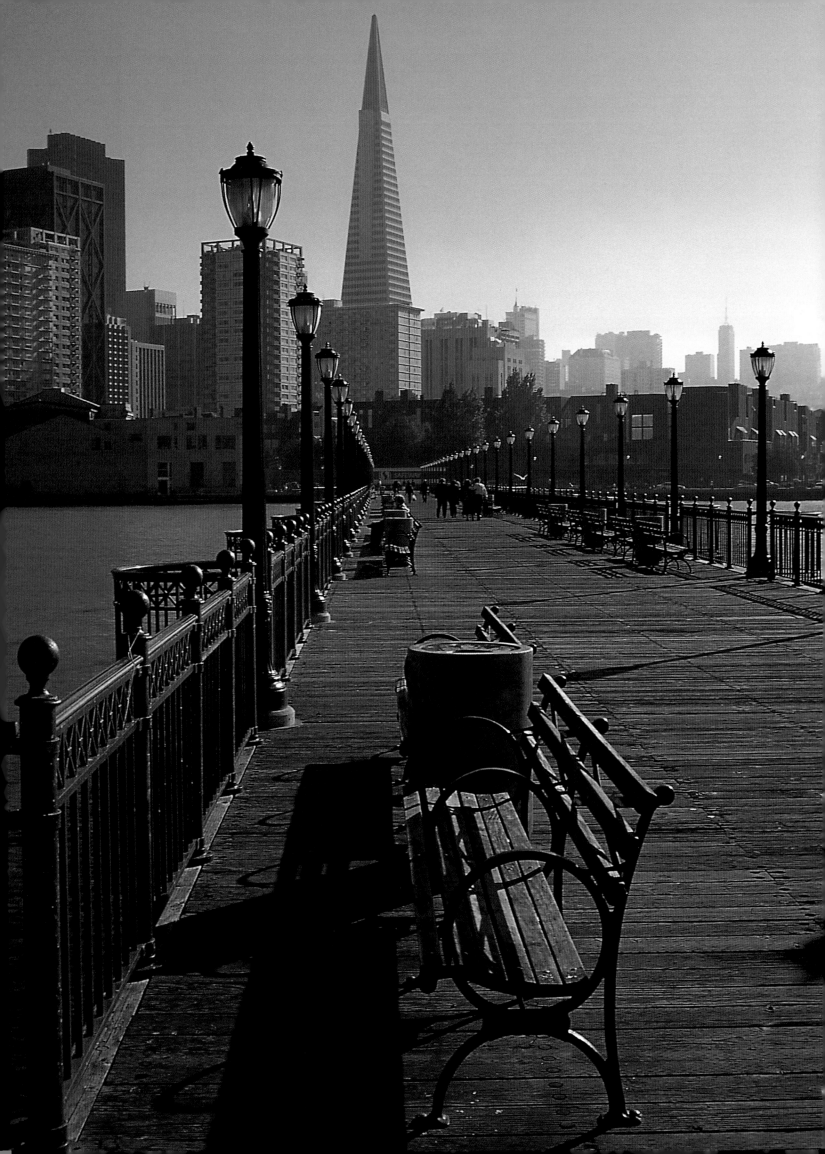

Similarly, San Francisco has both Fillmore at Broadway and Fillmore at Eddy. Both are part of the same street, both places are integral to the nature of our city, and both are hardly "average." San Francisco is as much its millionaires' view of the bay and beyond as it is the Jazz And All That Festival on Fillmore. In fact, jazz (Dixieland, Big Band, Bee Bop, and Latin) has been an especially vibrant contributor to our cultural traditions. According to legendary band leader Turk Murphy, "Musicians and girls [circa 1910] made a regular circuit between Storyville (New Orleans) and the (San Francisco) Barbary Coast." And this circuit,

at least for the musicians, will continue both in the thriving jazz and Latin jazz clubs around town and the proposed new jazz complex in the Western Addition (on Fillmore, incidentally).

The ethnic diversity that makes this city what it is can be seen in the number and kinds of festivals and events held throughout

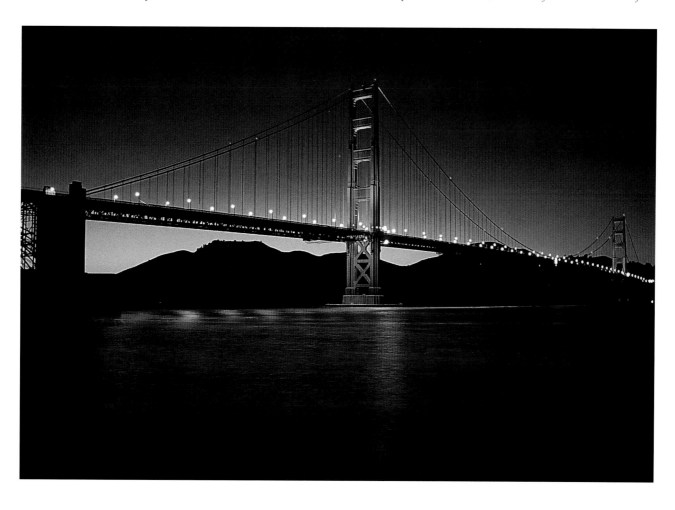

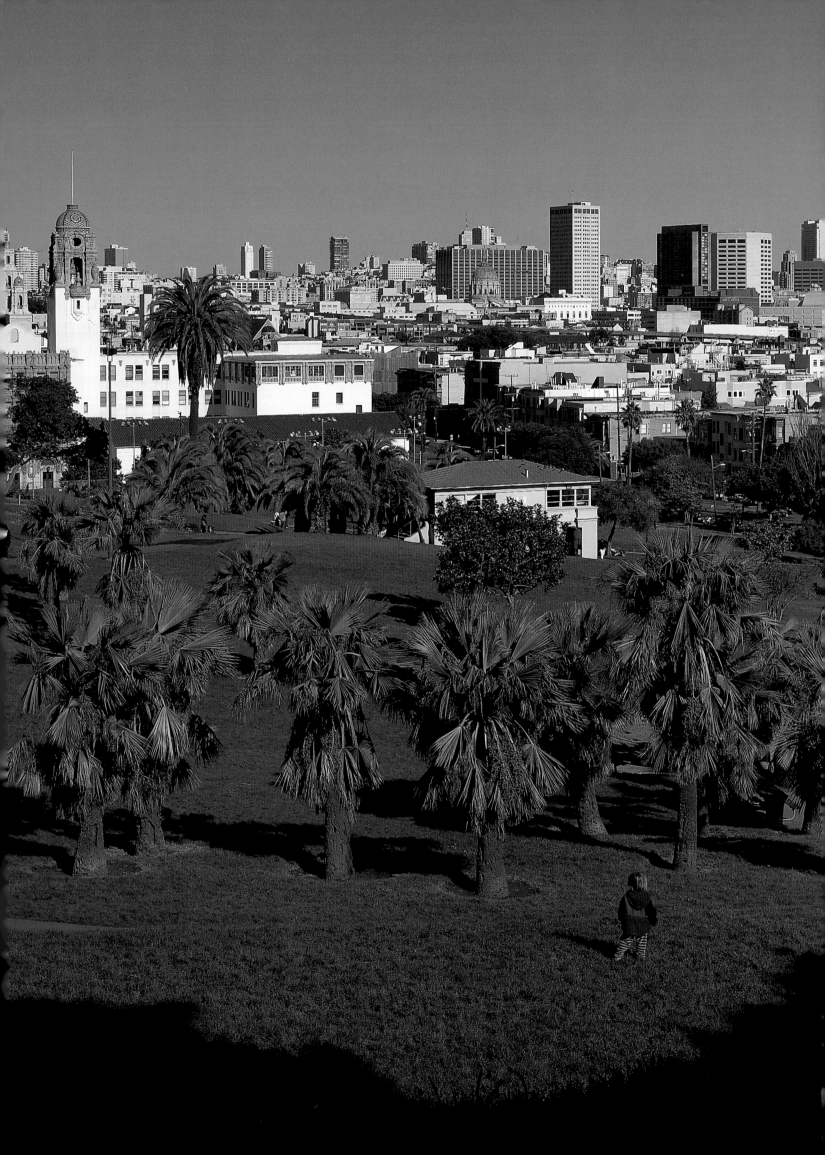

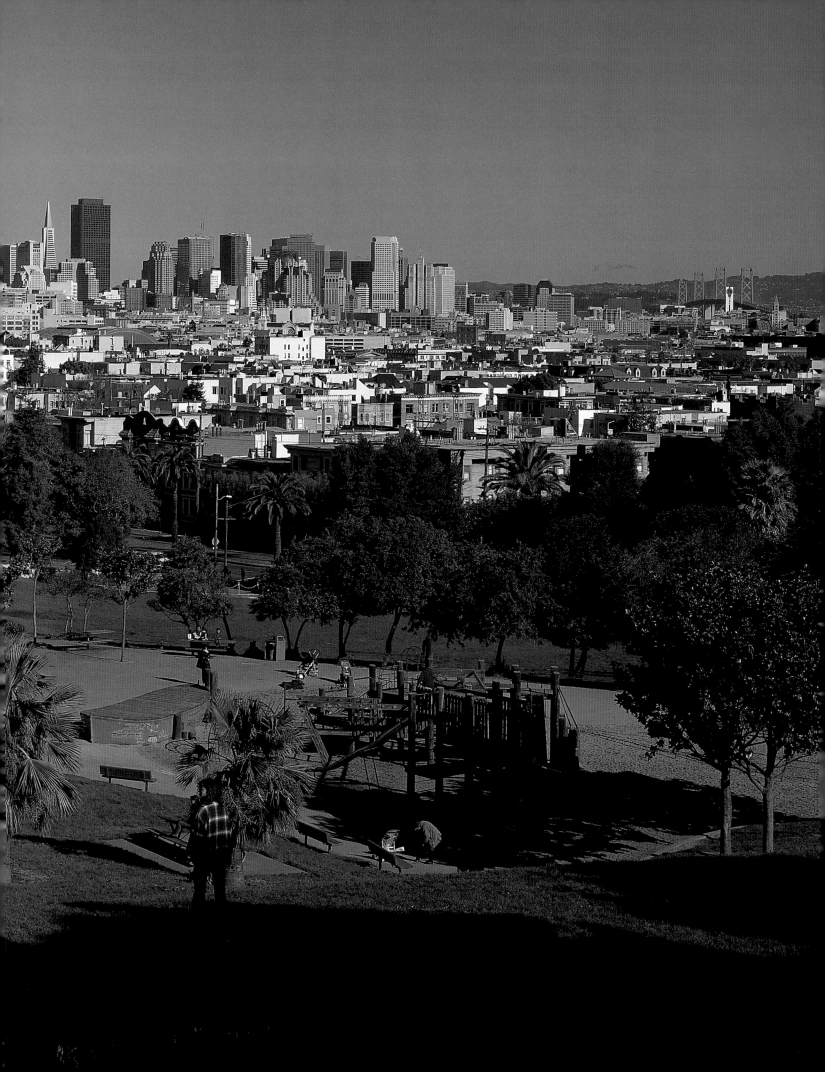

the year. The second new moon of our Western year, for example, rises felt but unseen on the Chinese New Year. On said occasion, the sulfurous smell of exhausted firecrackers mixes with the smell of oranges (the "fruit of fortune") as dragons, banners, drums, and crowds weave through the streets of Chinatown. And the celebration continues—a bit less formally—for two weeks. One evening while walking home from work, I was caught in a bit of this less formal "fire." Two balconied high-rises facing each other became the juvenile battleground for volleys of firecracker rockets. They are quite illegal, rather dangerous, and a kick to watch arcing and sparking across a busy street at sunset.

On the other side of the year, a less well advertised (though by no means less interesting) celebration occurs. *El Dia de los Muertos* (the Day of the Dead) is observed as the Mexican equivalent to All Saints Day. A candlelight parade of gorgeous/goulish costumes weaves through parts of the Mission District. There is music, wonderful music, and dancing, wonderful dancing, and an abundance of good food—including the dessert of the day, sugared skulls.

We host a Grand National Rodeo where the good ole boys and girls can wear their chaps and hats and an Exotic Erotic Ball where the good ole boys and girls can wear chaps and hats and not much else. Our namesake, Saint Francis of Assisi, is

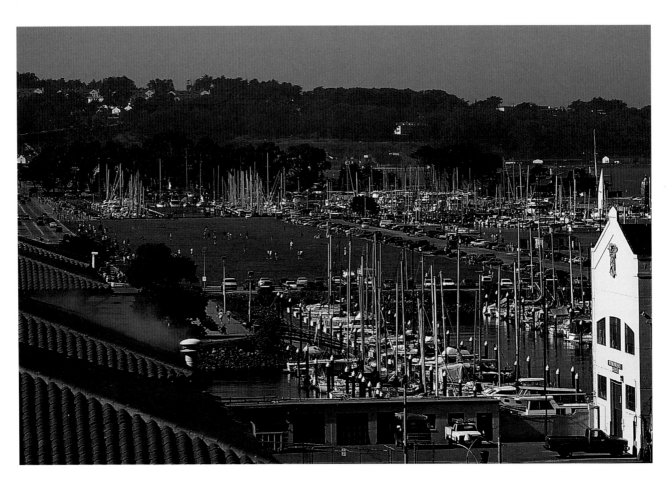

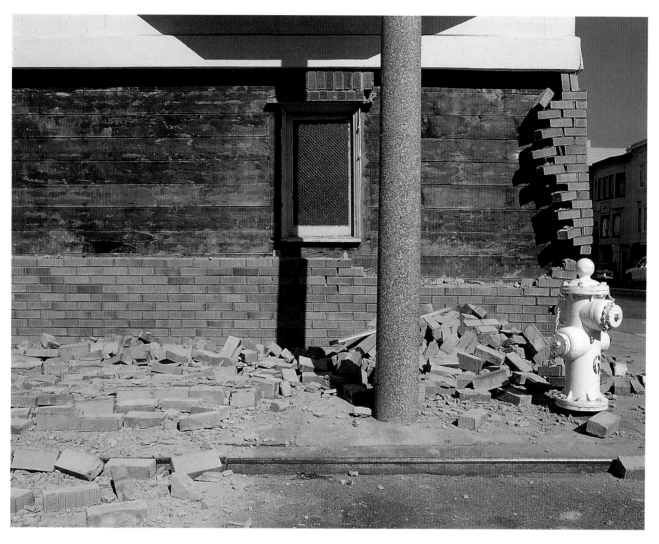

FACING PAGE: *Working schooners have given way to pleasure sloops along the Marina Green. The famous Saint Francis Yacht Club is tucked amongst the masts in the distance.* ABOVE: *Liquefaction and its effects:*

On October 1, 1989, the San Andreas Fault shook almost one hundred miles away and the unstable landfill under the Marina District turned to a Jell-O-like liquid—not a great place for a brick wall in a shake.

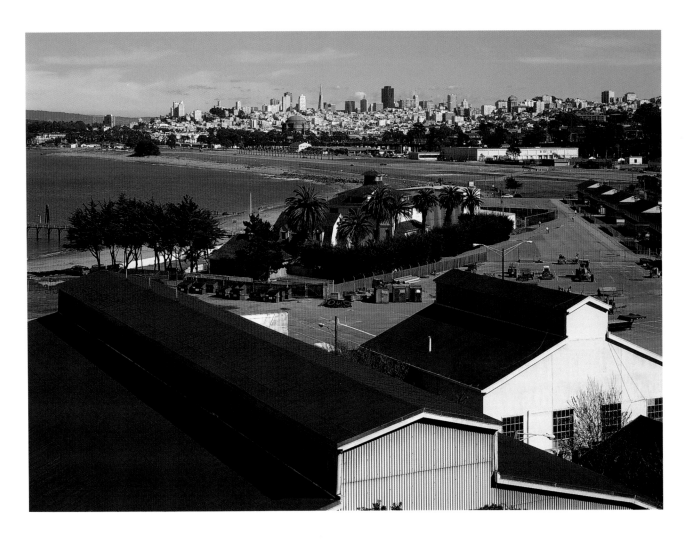

celebrated at Grace Cathedral on a meow-ing, barking, squawking occasion when people bring their various pets to be blessed at Easter, while in mid-summer, inimitably led by the famous "Dykes on Bikes," we celebrate Lesbian and Gay Freedom Day up and down the rainbow-bannered Market Street.

If more's revealed in contrast than in isolation, the weekend nearest to May 5 is quite revealing. On one side of town, we observe *Cinco de Mayo,* the day Mexico celebrates its independence from colonial intrusions while, on the other side of town, we celebrate "Opening Day on the Bay," an event hosted by the St. Francis Yacht Club. On this day, sailors hank on their jibs and

tighten their stays for the first big race of the season. It usually doesn't get much better than this in San Francisco. Typically, there has been a bit of morning fog and typically, by noon, it has burned off. As the sweet corn smell of *masa* fills the air and the claves of the first Salsa band start to tap the *guaguanco,* the wind has already begun to freshen on the bay. Crews hike a little further out and the narrow bows start to zigzag toward the wind, toward the Golden Gate, and toward what the Ohlone, the last first inhabitants of this remarkable place, called the "Sundown Sea."

Nothing, however, typifies our luxuri-ous variety like the food we like to eat. A few simple and illustrative stats: we have more restaurants per capita than any other city in

America; we spend more on food than folk do in any other American town; and were we to eat out every night of the year at a new restaurant, it would take us nearly ten years to try them all.

Though current trends tend in all sorts of directions, there is fairly general movement in one general direction. Living, as we do, in the middle of "Californicopia," we are increasingly addicted to food that is both fresh and varied. The grapes for the wines, the fish, the crabs, and the oysters, the fruits, the vegetables, the beasts that walk and the birds that fly are often raised within an hour or two's drive (or sail) from our tables.

And what are some trends that tend toward our tables?

There's the neo-classical "meatloaf and potatoes" for fifteen dollars; the once-was-a-Cantonese-now-is-a-Szechuan restaurant serving increasingly spicy fare; there is the ethnic-combo restaurant that marries two or more distinct approaches to taste—usually with note-worthy results; and there is the standard "nouvelle cuisine" with a California twist. These are the flamboyant "vertical

FACING PAGE: *The Presidio's strategic position on the Bay made the ideal spot for various military installations. With the military now gone, it is poised to provide any number of well-placed "installations."* BELOW: *This lovely Gothic-styled church in the Noe Valley area was, for obvious picturesque reasons, used as the setting for much of Whoopie Goldberg's film, "Sister Act."*

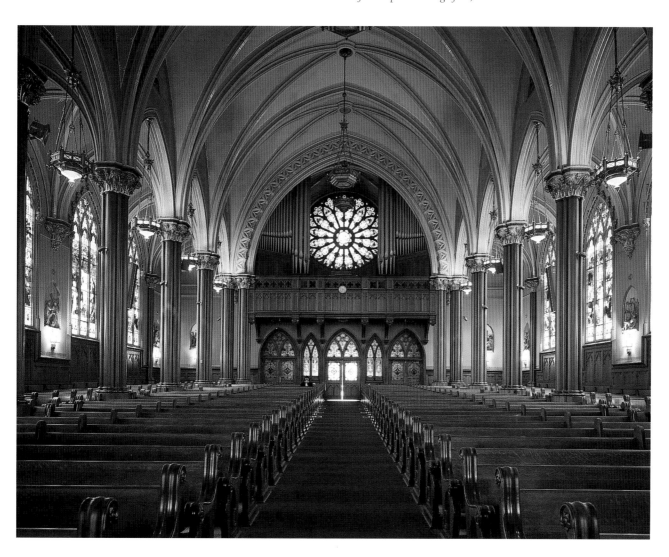

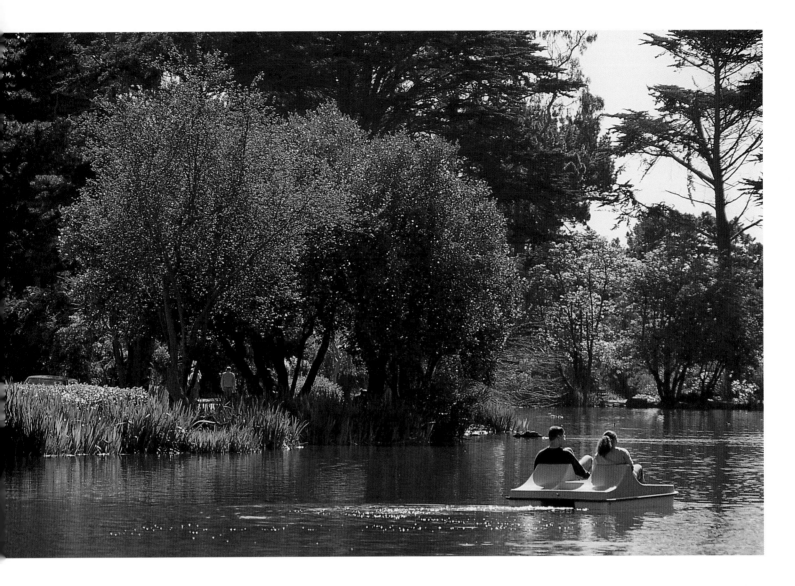

creations," roller-coasters of julienned vegetables, strata of starches, peaks of greens, and valleys of sauce—the culinary equivalents of our vertiginous landscape.

Even the descriptions can make you a little dizzy, particularly if you are not absolutely fluent in "Food": e.g., "Sumac dusted Lamb Loin with couscous and eggplant tapenade" or "Maine Lobster served on buttermilk mashed potatoes with lobster sauce, corn relish, and a tumbleweed of crispy leeks, zucchini, and haricots verts" (tumbleweed?!) or "Grilled Pancetta wrapped Sweetbreads with lentils, rocket, radicchio chiffonade, and roast red pepper relish" (rockets and radicchio!!!)

OK, so it's a little excessive, at least in words, but the result for the tongue can be revolutionary. But is this where our

revolutions have landed these days—on our plates and not in our streets?

Che Guevara, describing how difficult it was to keep a gorilla force in the midst of a jungle, suggested that worse than sentimental chat about girlfriends or family was the deeply distracting chat about food. "Nostalgia," he despaired, "begins with food."

Perhaps this is San Francisco's greatest cultural malaise, "nostalgia," and NOT just

ABOVE: *Water, water everywhere—and most of it for pleasure. Paddleboaters meander around Stow Lake in Golden Gate Park.* FACING PAGE: *A vestige of the style of life at the top of the hill, Nob Hill—this delicate detail is part of the fence surrounding the mansion of James Flood, one of the silver kings. His was the only mansion in this part of the city to survive the the earthquake and conflagration of 1906.* FOLLOWING PAGES: *The Conservatory of Flowers in Golden Gate Park is a Victorian jewel of wood and glass. It has been able to ride out our earthquakes, but the wind has occasionally sent its panes flying.*

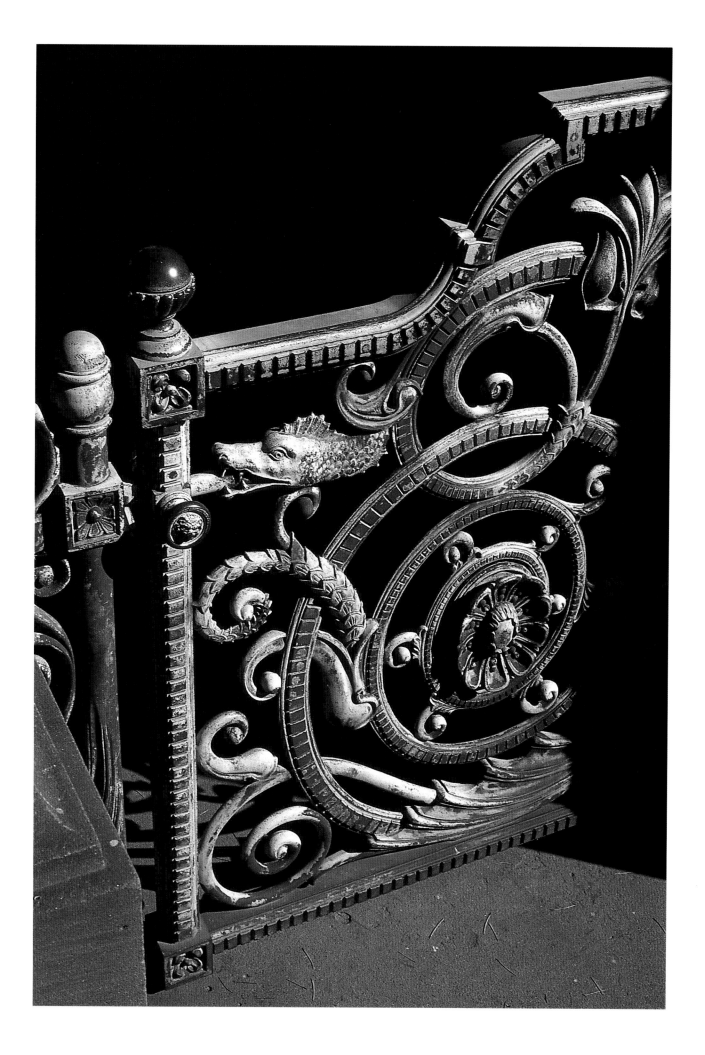

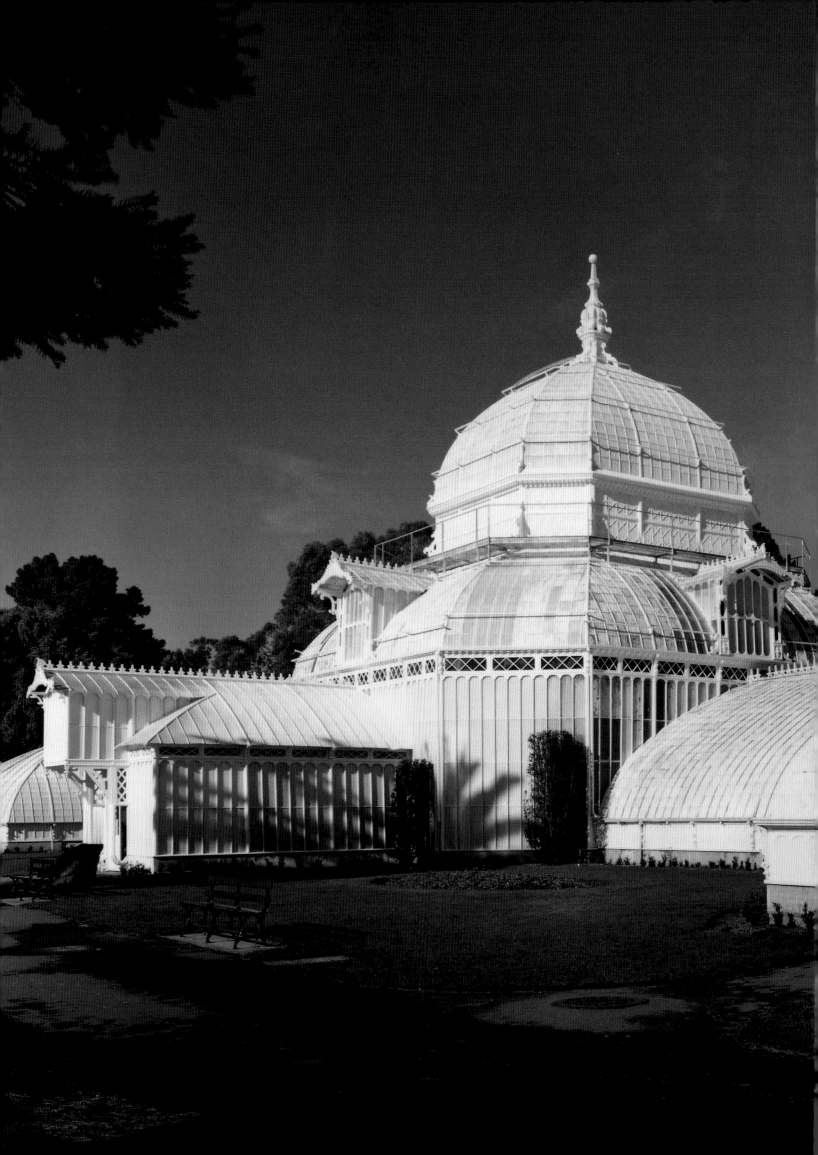

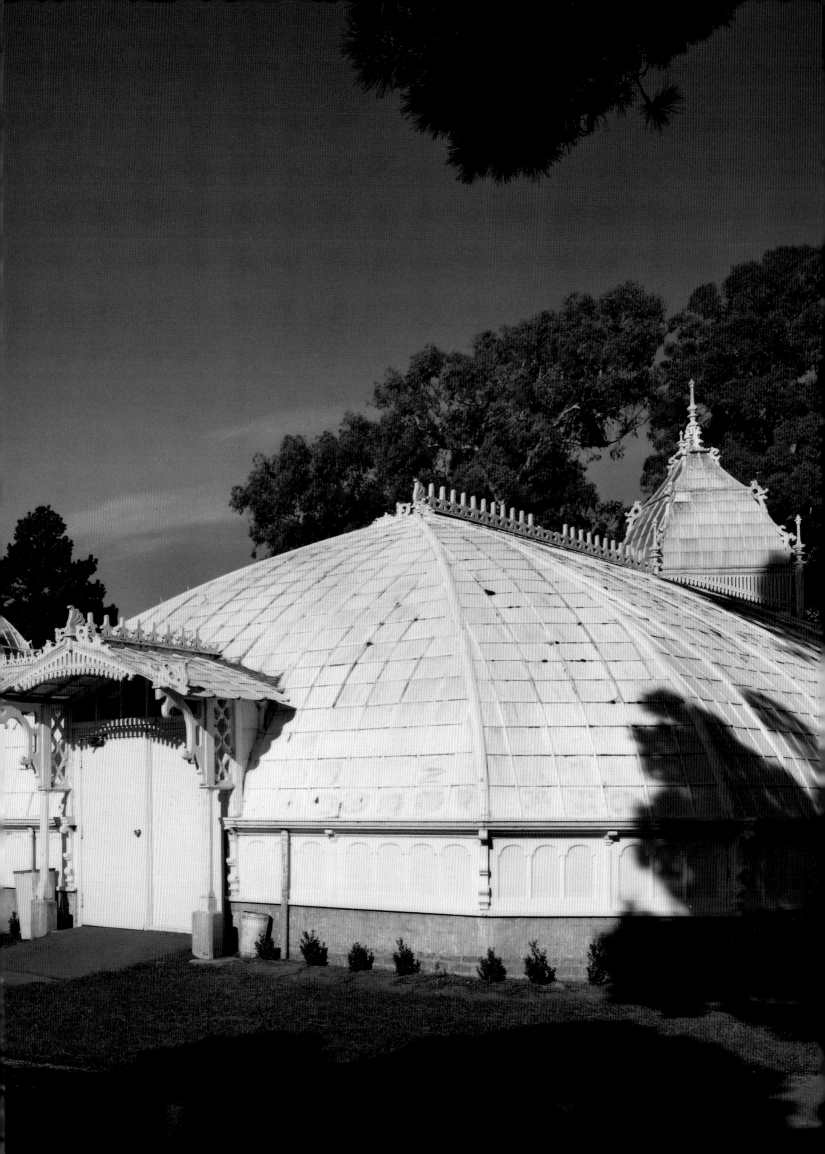

for food. We are sometimes overly precious about our traditions. And others, not from San Francisco, are often overly sentimental about the whole experience. Tony Bennett and that song about "leaving the old ticker in San Francisco" certainly catches the drift.

So we've got two great bridges, a gorgeous bay, a gorgeous ocean, a whole lot of parks, and a whole lot of very pretty hills? So what that despite the 1906 earthquake, we still have over fifteen thousand Victorians to look at and that even our modern architecture is world renowned? So we are a city with a past—raunchy, racy, rich, and rebellious? Is it really all that important that for Jack Kerouac and his pride of insouciant "Beats," the next best place to being "on the road" was being off the road here? And so what that the "Summer of Love" happened here and that the Winterland rocked with the "grooviest" roll call of the decade?

The question is, are we now no more than scenery and sentiment with a taste for good food?

I don't think so.

For better or worse, not all eyes are on one poet (and his adoring crowd), not all ears are on one song (and its revered band). Many eyes and many ears are on many

FACING PAGE: *Local boy makes good ... food. Arnold Wong concocts remarkable combinations at his new restaurant, Eos, having learned the joys of fresh ingredients from his Chinese-born father, Walter Wong, of the inimitable Ashbury Market.* BELOW: *Another favorite for "food with a slant" is the Zuni Cafe, kinda Southwestern, kinda French, kinda New Californian, and definitely San Franciscan.*

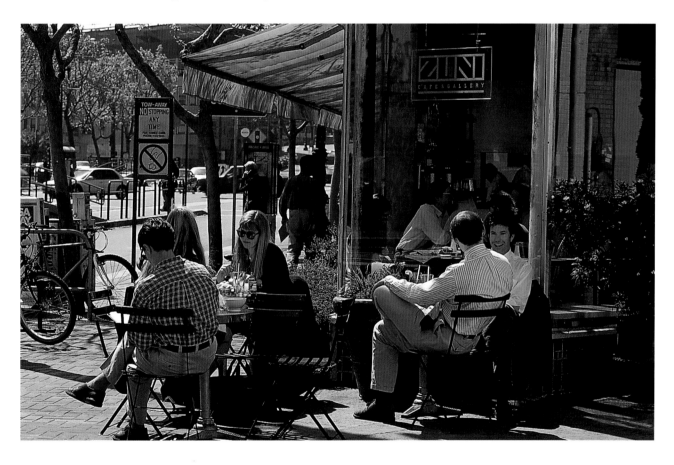

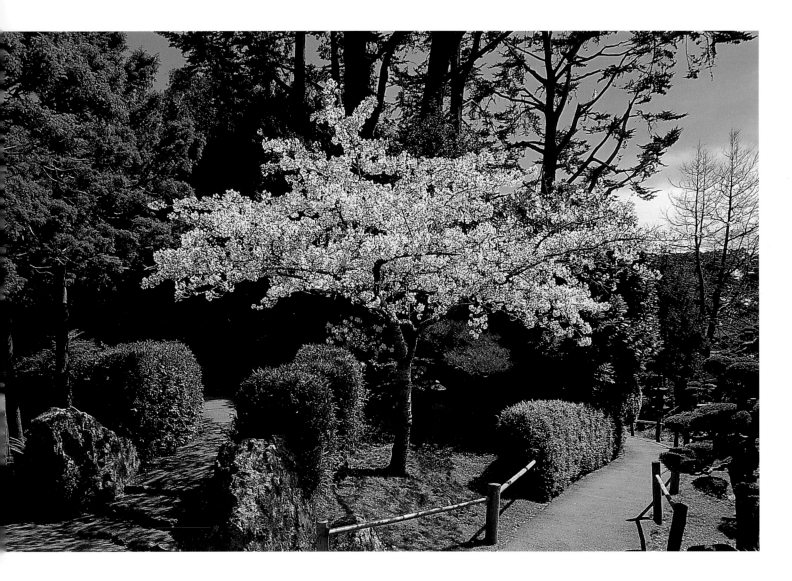

different things. And this is where San Francisco is still alive and "revolutionary."

E Pluribus we most certainly are—in sheer numbers, more so than most places, and in VIBRANT multiplicity, definitely more so than most places. We are like so many bits of fruit in a Jell-O mold, a thriving mixture of types and tendencies stuck together on a mere 46.7 square miles. If E Pluribus can become even more Unim without melting down the distinctions that make us what we are, then we'll pull off yet another cultural first—this time with the whole family along for the ride.

Tricky, this task, but by no means impossible. In fact, almost anything seems possible in San Francisco, where, in the words of an ancient Ohlone chant, we are "dancing on the edge."

ABOVE: *Cherry blossom time is celebrated with a flourish in the tranquil Japanese Tea Garden in the middle of Golden Gate Park.*
FACING PAGE: *Twenty-eight acres of land in the Presidio is dedicated to the National Military Cemetery.*

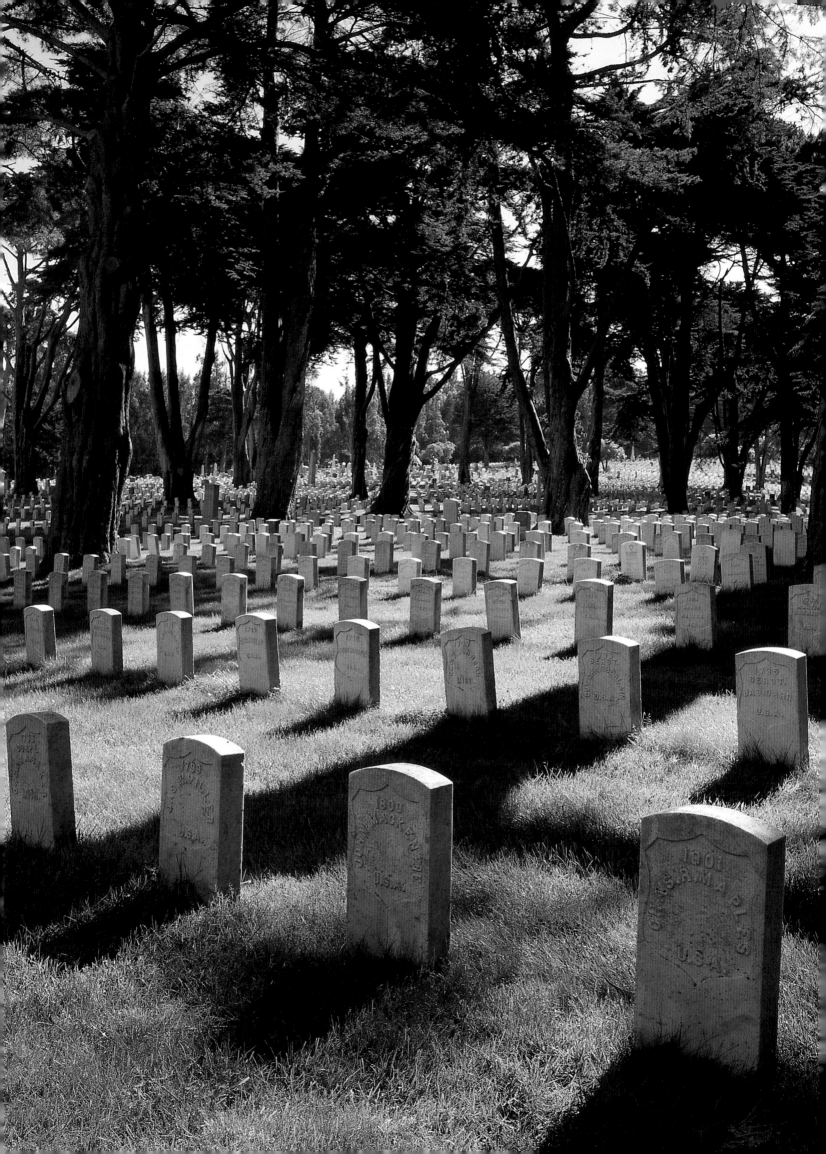

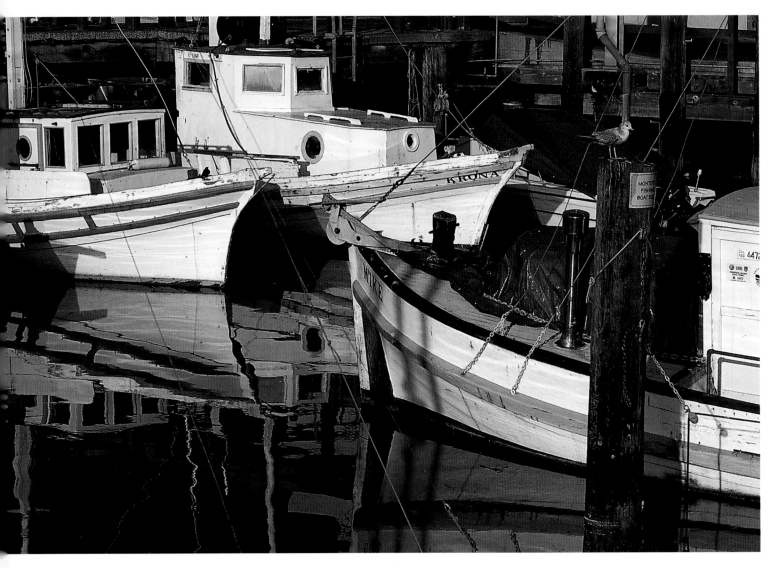

ABOVE: *The fishing fleet is somewhat smaller now than it was a few generations ago, but it supplies a thriving industry by bringing in the local salmon, crab, herring, bass, and other fresh delicacies of the sea.* FACING PAGE: *The first cable cars in the world were built in San Francisco to help deliver people and goods to the top of the hills.*

The goods may be gone, but the people still crowd onto this attractive— if laboriously slow—conveyance. FOLLOWING PAGES: *From the starboard bow of a schooner, one can look across the cool waters where, daily, members of the Dolphin Club ignore their goose bumps and swim with the seals in the relatively calm waters of Aquatic Park.*

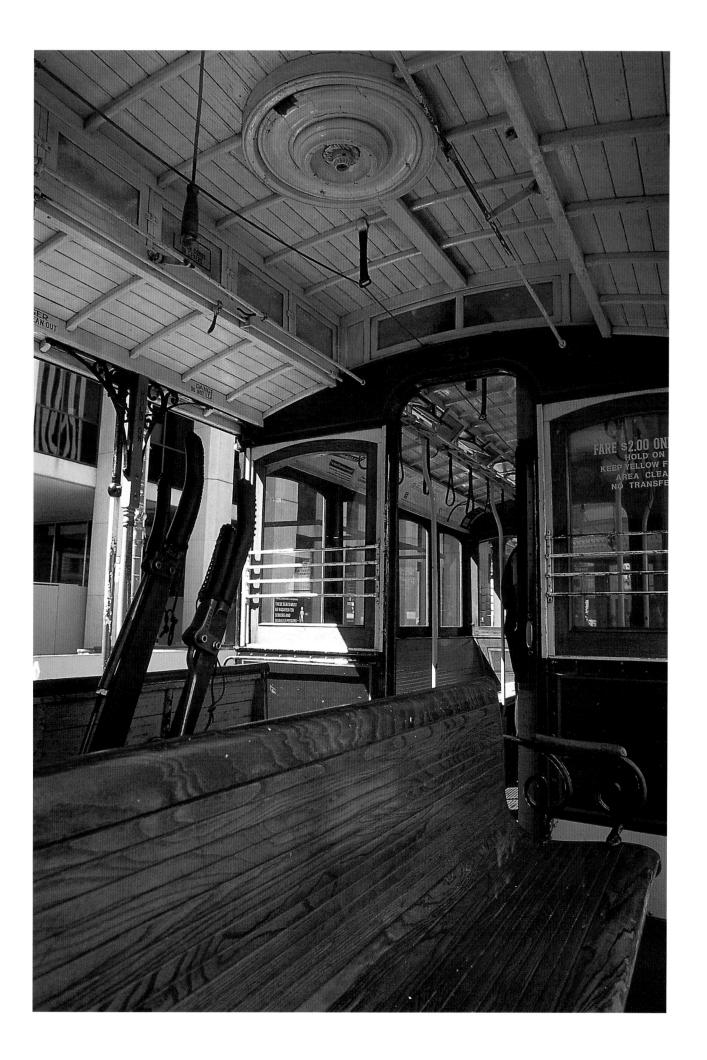

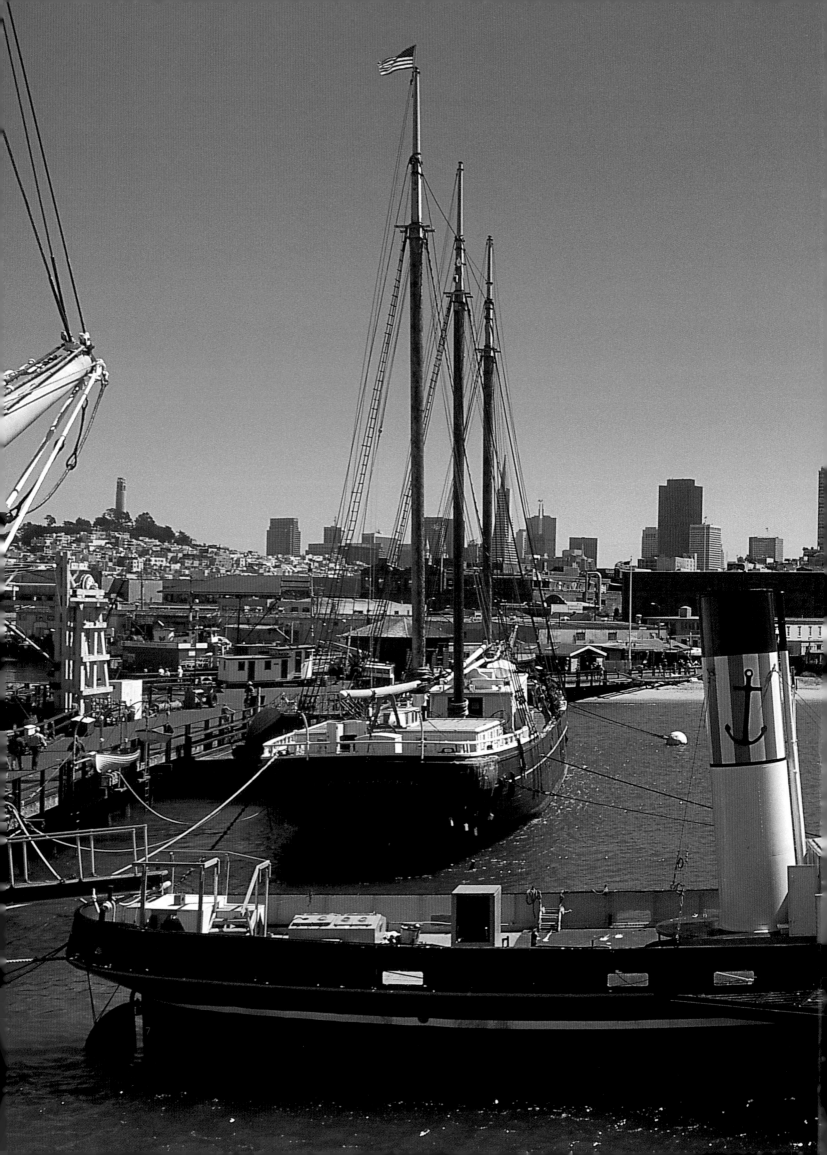

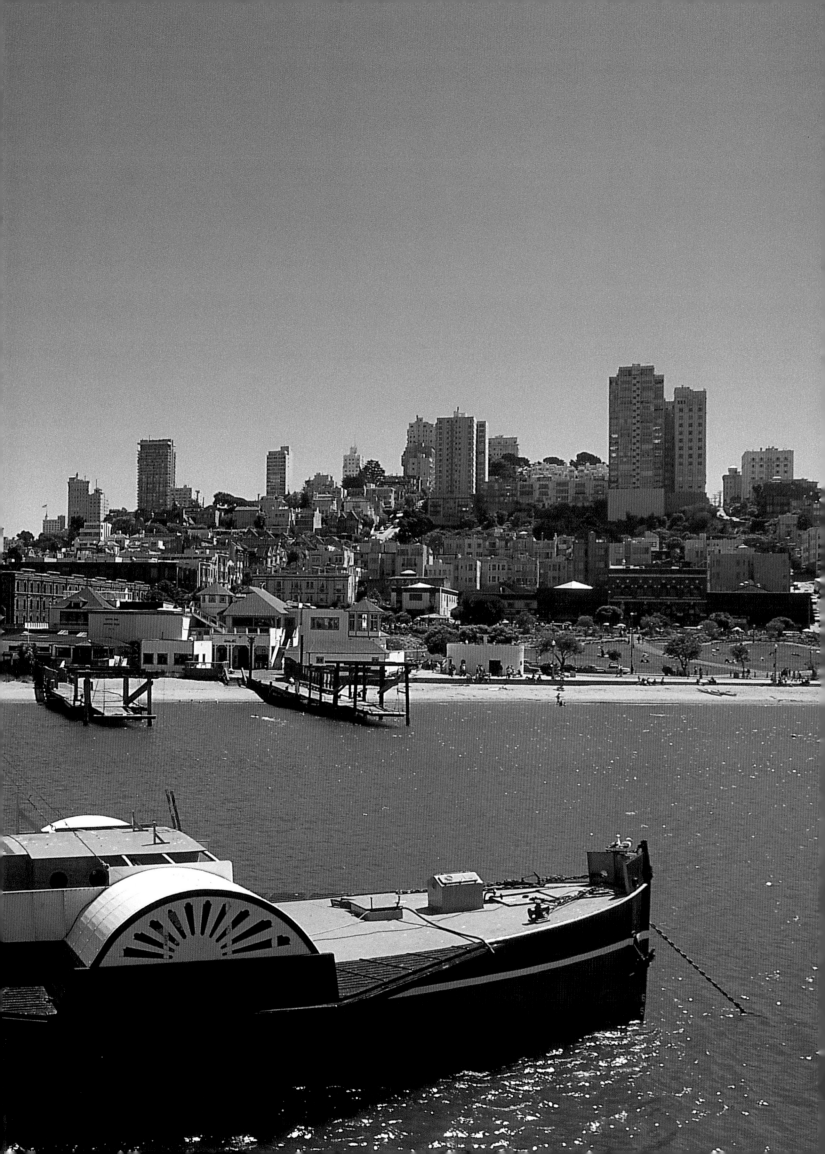

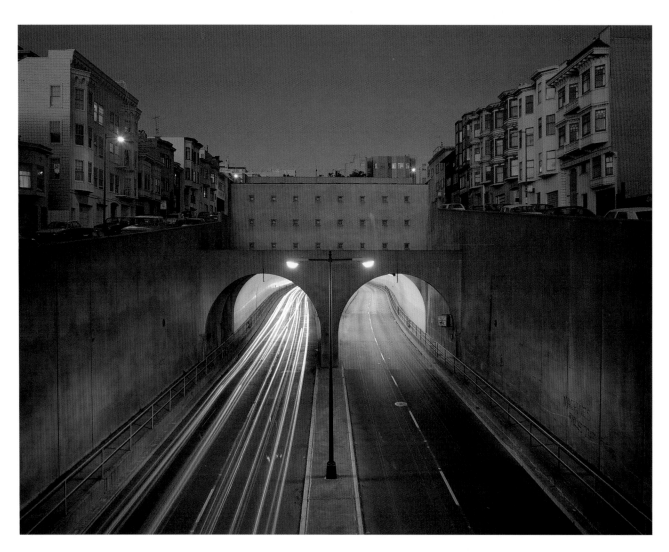

ABOVE: *The Broadway Tunnel was considered a great civic improvement because it was able, efficiently, to link the automobiled people of Pacific Heights, the Marina, and points west, with the* automobiled people of North Beach, Chinatown, and points east. FACING PAGE: *The lights come out in San Francisco while the light goes out over what the Ohlone Indians called "the Sundown Sea."*

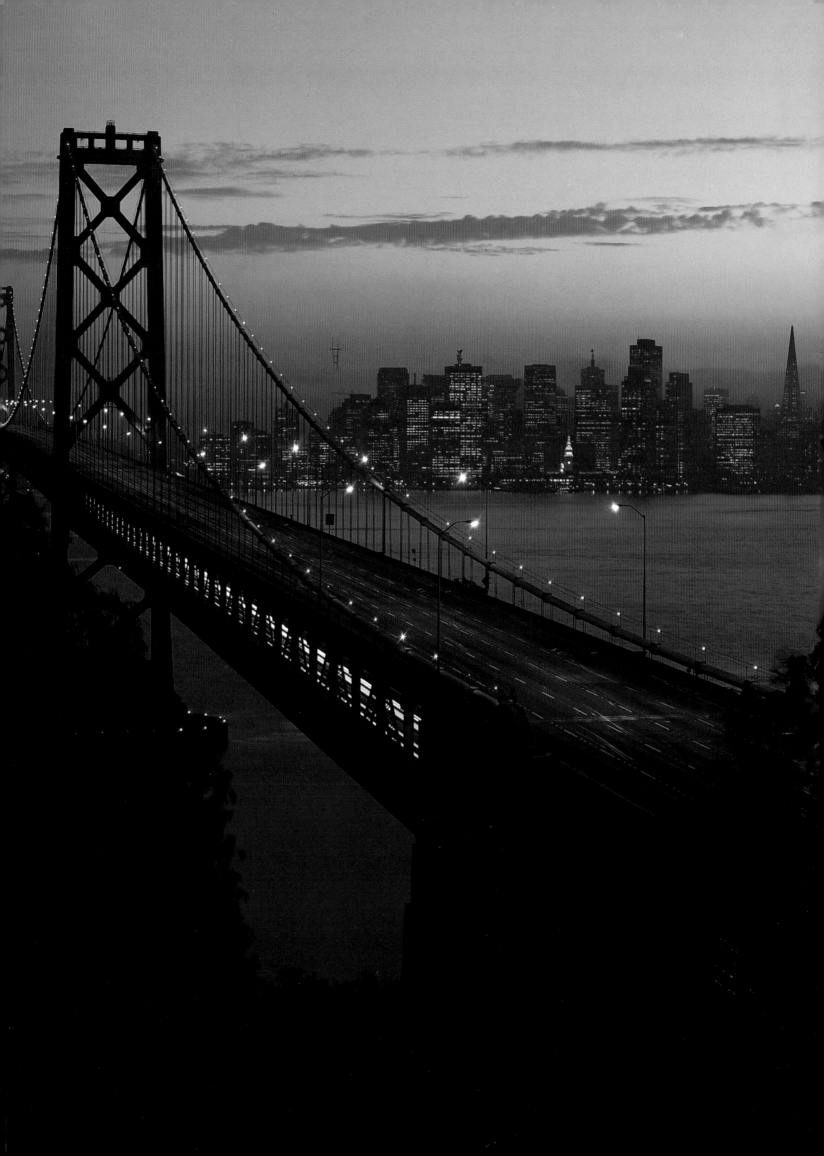

Acknowledgments

These photographs were taken over a period of more than ten years and could not have been made without the help and influence of many people. I am grateful to Ora Schulman, Jonee Levi, Harvey Hacker, Daniel Bacon, Diane Roby, Tom Drain, Kenneth Caldwell, Cecilia Brunazzi, Jessie Bunn, John Wheatman, Beth Roy, and JoAnne Costello. I am especially grateful to my wife, Sharon Smith, whose loving support, insightful suggestions, and generosity made this book possible.

DAVID WAKELY

The author would like to thank a few whose knowledge of San Francisco has added to his own greater knowledge of the city. Thanks to Rand Richards and his *Historic San Francisco,* Daniel Bacon and his *Walking San Francisco on the Barbary Coast,* and the Association of Bay Area Governments that diligently keeps track of San Francisco's vital signs. Finally and, as always, mostly, I thank my wife, Ora Schulman, for her loving and intelligent support and my two young sons, Joseph and Nathaniel, for their patience.

DAN HARDER

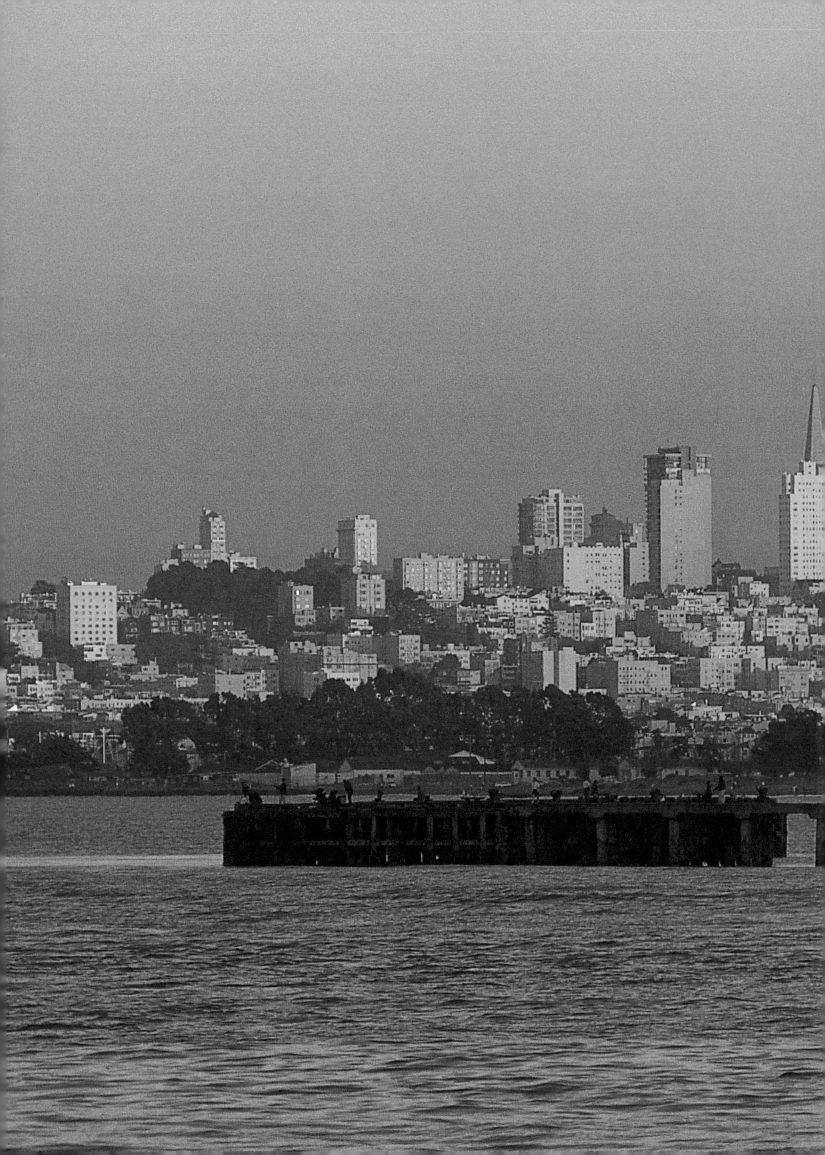